By Gaslight in Winter

By the same author
A Richer Dust

Opposite: A view of Windsor

By Gaslight in Winter

A Victorian Family History through the Magic Lantern

Colin Gordon

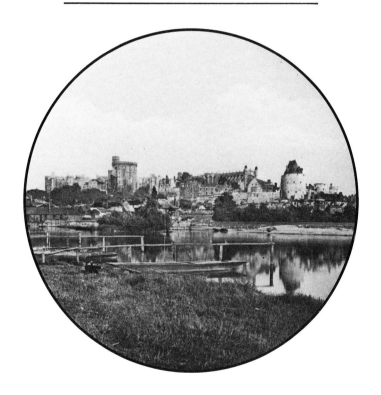

Designed by Craig Dodd

Elm Tree Books · London

For Rose

First published in Great Britain 1980
by Elm Tree Books/Hamish Hamilton Ltd
Garden House, 57–59 Long Acre,
London WC2E 9JZ

British Library Cataloguing in Publication Data
By gaslight in winter.
 1. Riley Bros. – History
 I. Gordon, Colin, b. 1944
 338.7'68'1418 HD9999.P/
 ISBN 0-241-10474-2

Printed in Great Britain by
Lowe & Brydone Printers Ltd, Thetford, Norfolk
and Ebenezer Baylis & Son Ltd
The Trinity Press, Worcester, and London

Contents

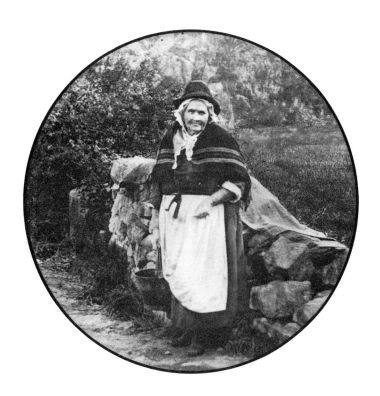

Welsh Peasant Woman

(from *North Wales*)

Acknowledgements

The author and publisher are very grateful for permission to quote from William Riley, *Sunset Reflections*, Herbert Jenkins, 1957.
The photograph on page 23 is reproduced by permission of the Science Museum, London.

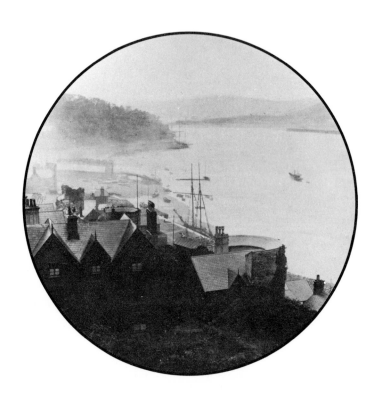

Conway

Introduction

Of all the relatives of my grandparents' time, Great Uncle Jack occupies a special niche in my imagination. I never met him; he died before I was born. And I have only ever seen one photograph of him. However, he worked in Africa on a plantation in the days when missionaries and school books called it 'darkest'. That lent Great Uncle Jack an air of mystery denied to his greyer peers who worked in corn or cotton in Liverpool. And, best of all, there was in my grandparents' attic a tangible relic of Jack — a box of glass lantern slides: pictures of piccaninnies with distended bellies, staring wide-eyed for the magic box, their mothers shamelessly (to my grand-parents' eyes) airing their chidren's nakedness. Uncle Jack's lantern slides were an unfailing source of diversion to us grandchildren; lantern slides in general acquired for me a charisma which transformed them beyond mere records of the past.

Much later, when I acquired a more than anecdotal curiosity in Victorian photographs, I learned that Great Uncle Jacks were legion: few family archives were respectably complete without at least a handful of glass lantern slides as evidence of great-grandpeople who could afford to travel widely before the motor car was born. Junk shops, too, offered remnants of slide sequences for sale — usually tedious remains of school geography resources illustrating 'Life in Many Lands', or Sunday-school relics in the form of illustrated hymns. Slides which worked as pictures in themselves or which led to a good story seemed very hard to find.

In June 1977, however, I heard of a collection of 'some' lantern slides at an auctioneer's house outside Leeds. Not expecting to be surprised, I arranged to see them. On an outhouse floor, swooped over by nesting swallows, stood a squat mountain of 700 wooden boxes, each containing about 50 glass lantern slides — in all, about 35,000 slides, mostly hand-coloured on a black-and-white photographic base. Diversion enough here for a whole army of grandchildren! Though many of the slides had been ruined by damp, and many of the original lecture notes crumbled into dust on touching, enough remained to be worth investigation. And on many of the boxes was stamped the name, 'Riley Bros., Bradford'. Who, then, were the Rileys?

Godwin Street in Bradford, Yorkshire, runs down hill to the city centre. In another sense, one particular building in the street has been going down hill since the turn of the century. Nowadays Godwin Street is part of a confusing, one-way traffic system and motorists are, therefore, likely to be too busy choosing the right lane to notice much decline in the buildings. You would have to look closely to pick out, halfway down, the entrance to a Victorian building now sandwiched between a boutique and a failed furniture shop. Above the door is a small, simple nameplate which reads, 'Godwin Chambers'. The name suggests elegance and dignity; but now the building is decayed and shabby. Inside, the light-blue walls are dirty and pock-marked; and the cherry-red paintwork only contrives to look garish. Many of the rooms on the rambling four floors are empty or filled with junk or the uncleared debris of office parties. In two of the rooms Edgar, Doris and Hilda run part-time dancing schools. But for most of the week the building seems deserted. The doors are locked — even those advertised as open. In all this dinginess, however, there is one reminder of more affluent times: up the centre of the building winds a mahogany and cast-iron banister, with all the assurance of a Bradford millionaire.

In fact, at the turn of the century, Godwin Chambers was the site of a commercial success story. In the 1890s the building housed the offices of 'Riley Brothers Limited', makers of lantern slides, projectors and movies. Oddly enough, although the Rileys have long since departed, Godwin Chambers preserves a connection with photography: on the third floor a Studio and Model Agency advertises 'lovely girls for hire' — Rosa, Tina, Jaqui and a dozen or so more. Visitors are, however, deterred: on the studio door a warning in chalk threatens electric shocks to all those who try the handle.

But the family's name is not entirely forgotten. 'Riley Brothers Limited' was a large enough enterprise to be known to historians of photography. There are tantalizingly allusive references to the company in standard reference books and research articles — mostly in connection with movies, not lantern slides. The usual story told of the Rileys' film-making has that strange blend of fact and supposition which belongs properly to legend. In

one appealing version of the story young William Riley was invited to Paris in 1895 by the brothers Lumières, the famous movie pioneers, for the first showing of their moving-picture show. On a small white screen in the unpretentious basement of the Café Grand, Riley saw a flickering train draw into a country station, where passengers jerkily alighted and embarked. There followed, incongruously, a bedroom scene, 'realistically and characteristically' French. Thrilled by the possibilities of this miraculous novelty, William Riley rushed back to Bradford to commission Cecil Wray (a manufacturing optician who worked at Borough Mills) to make a camera-cum-projector for the Rileys' own company. But Cecil Wray had already filed a patent for a 'kinetoscopic projector' on 3 January 1895 — one of six camera-projectors patented that year.

The Kineoptoscope by Riley Brothers

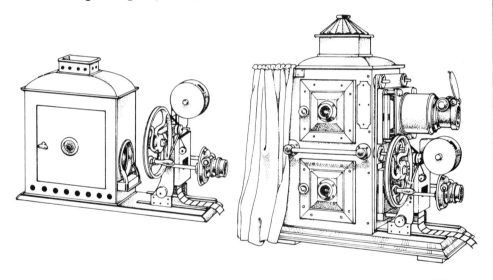

Another version of the story says that Jean le Roy (an associate of Louis Aime Le Prince, another movie pioneer) demonstrated his own cinematograph invention in the Rileys' New York offices early in 1895. But, however it came about, the Rileys patented their own 'Kinetoscope' and its improvement, the 'Kineoptoscope', in 1896. By 1897 the Rileys owned a movie camera and, with Bamforths of Holmfirth (famous lantern-slide and postcard manufacturers), between 1897 and 1900 made a dozen or so 'RAB' two-minute filmstrips, figuring such comic banalities as the escapades of boys in snowball and pillow fights.

These passing references to the Rileys in official histories of the cinema and especially the mention of their 'New York offices', confirmed the scale

of their enterprise. But on the origins, growth and decline of the firm — the human face of the story — historians were unanimously silent.

The bare bones of the family skeleton, however, lay buried in street and trade directories of the late nineteenth century. In Slater's West Riding Directories for the years 1887 and 1891 appear two crucial entries:

> 1887 Riley, Joseph and Samuel B., stuff manufacturers; 5, Cheapside, Bradford.
> 1891 Riley, Joseph and Samuel B., stuff manufacturers and photographic material dealers; 5, Cheapside and 14, Tyrrel Street, Bradford.

Sometime around 1890 two Bradford brothers (?), happily established in a booming textile trade (two stuff or textile merchants are recorded in Bradford in 1815; 252 in 1893) suddenly embarked on an extraordinary diversification. Nowadays we are not surprised to see that such things as wallpaper and weedkiller bear the same trade name: syndication and take-overs are facts of commercial life. But what impulse lay behind the Rileys' new departure, as odd as if a civil engineer started selling pressed flowers?

In apparently dull lists of the names of streets, trades and people in directories by White, Kelly and Slater appear other hints of the shape of the Rileys' story. 'Photographic material dealers' became 'magic lantern outfitters and manufacturers'; moves from premises to premises suggest fluctuating fortunes; between 1898 and 1900 the magic lantern business became a limited company; in 1914 the company changed its name; from 1903 the Rileys are no longer recorded also as stuff manufacturers; and, after the last reference to the Rileys' magic lantern business, is a solitary mention in 1928 of 'Riley and Riley, wireless dealers'. As for the actors in this drama of business, the list of those Rileys with 'Bros.' in brackets after their names amounts to a bewildering tribe: Joseph, Samuel B., Herbert Jowett, Willie, Arnold Henry, and Bernard. They move their home addresses around the suburbs of Bradford as if predisposed nomads. And they try their hands at other occupations, such as 'optician' or 'grocer', as readily as Cabinet Ministers change portfolios. Where exactly do the Rileys fit in the history of the magic lantern?

The paternity of the magic lantern is traditionally foisted on a seventeenth-century Jesuit priest, Father (appropriately) Athanasius Kircher, who first outlined the principles of projection with a lens in his *Ars Magna Lucis et Umbrae* (1646). 'Fatherhood' is probably here, as is often the case with 'inventions', a misleading metaphor. Kircher's 'discoveries' were developments of the precocious work of the Neapolitan, Joannes Baptista Porta (inventor of the camera obscura), whose *Magia Naturalis* was published when he was only fourteen. But at least Father Kircher was probably the first to startle an audience by slides, projected on to a taffeta screen. By manipulating his pictures, painted on long strips of glass, he could even suggest movement; however rudimentary, this would in the audience's eyes, validate the epithet 'magic' applied to the instrument.

There are, in fact, some earlier recorded sensational optical shows which to the non-superstitious mind suggest that the showman (regarded contemporarily as sorcerer and/or priest) had a useful working knowledge of projecting images. The most famous incident is recalled in the memoirs of Benvenuto Cellini. Though better known as a Florentine artist and musician than as dabbler in necromancy, Cellini numbered scientific curiosity among his many talents, like a true Renaissance man. He invited a Sicilian priest in Rome to show him something of his skill in black magic. At the dead of night in the Coliseum, enveloped in magic circles, smoke, flames, incense and incantations, Cellini and his companions saw 'many legions of spirits', 'warlike men' and 'four, huge giants', which resigned at least two of the onlookers, including, apparently, the magician himself, to inexorable death. Cellini, however, forced on a braver mien and dismissed the apparitions as only 'smoke and shade'. However, his dreams that night were haunted by devils; he declined to accompany the priest on further enterprises; and, one turbulent month later, in the arms of his beloved Angelica, Cellini remembered that the devils had prophesied that he would be reunited with Angelica within the month.[1] Actually, the whole performance in the Coliseum was doubtless a tribute to the skill of the priest with a concave mirror, whose image-making properties had been known since classical times.

From the time of Father Kircher until the second half of the nineteenth century, the magic lantern (and hand-painted lantern slides) belonged firmly in the world of sensational and vulgar entertainment, among the grime of the street rather than the finery of the salon. The very name of one popular lantern show, the 'Phantasmagoria' (so named in 1802 by M. Philipstal who, appropriately, was rumoured to have dabbled in alchemy) is redolent of its ghoulish appeal: thunder and lightning, darkness, ghosts and skeletons. Small wonder that Harriet Martineau, popular early Victorian writer and friend of the Wordsworths, remembering the magic lantern shows of her childhood, recalls the physical dread:

> I used to see it [the lantern] cleaned by daylight and to handle all its parts, understanding its whole structure; yet such was my terror of the white circle on the wall and the moving slides that, to speak the truth, the first apparition always brought on a bowel complaint; and, at the age of thirteen, when I was pretending to take care of the little children during the exhibition, I could never look at it without having the back of a chair to grasp or hurting myself to carry off the intolerable sensation.[2]

Actually, Miss Martineau was confessing to the secrets of her own fragile constitution as much as to the horrors of the magic lantern. From early childhood she was plagued by nervous debility and indigestion; she also suffered from deafness and claimed never to have possessed the senses of taste and smell. Her eyes, therefore, were in compensation acutely sensitive and she doubtless felt the garish colours of the lantern slides like a physical blow. In the 1840s Miss Martineau's chronic disorder was 'cured' by mesmerism.

There is, however, no shortage of other evidence that lantern shows were, even for those of balanced disposition, ghoulish, bizarre and freakish. Operators of sophisticated lanterns in the 1890s recalled the clumsy instruments and crude painted slides of their boyhood:

> This was the age of the man with mouth and nose of distorted form and portentous size, of the woman attired in coal-scuttle bonnet . . . the features of both being of supernatural hue, the cheeks, lips and nose florid to a degree . . . Punch, clown and harlequin.[3]

One gruesome favourite, especially among young boys, was the 'man-eating-the-rats' sequence. 'A.R.W.' remembered using it to start his first ever lantern show at a village fair; the audience stamped and shouted so much that the screen fell down and broke his lantern.[4] No less a person than the Chairman of the Magic Lantern Society in 1891 dated his enduring fascination with slides from first seeing the vermin swallower 'some time

in the 50s' in the village hall at Wixhall, Shropshire:

> Such a crowd. All the blankets and bedquilts in the neighbourhood were used in darkening the innumerable windows of the schoolroom, which was a very large one, capable of holding some hundreds. The falling snow, Babes in the Wood, all these things paled before the final climax — the man swallowing rats. With the other boys I started counting . . . It was very wonderful. I always had a curiosity about a lantern after that day.[5]

(Such grotesquerie was not limited to the lantern: audiences could see the same in the flesh, as it were, according to Henry Mayhew, co-founder and editor of the then radical *Punch*, and chronicler of the life of London streets around 1850.)

By the 1890s serious advocates of the lantern looked back with aloof embarrassment at what they regarded as these degrading early spectacles: 'Such slides as a man eating rats are now out of date and are accountable in great measure for much of the unpopularity of the lantern with persons possessing the slightest artistic taste.'[6] Henry Mayhew had a closer first-hand knowledge than most of the world of popular street entertainment here so slightingly dismissed. In one of his excursions Mayhew met a man who showed canaries called Mr and Mrs Caudle; they rode in chariots pulled by goldfinches. There were mice, too, trained to dance the tightrope on their hind legs with balance poles in their mouths. Mayhew also interviewed an 'Old Street Showman' whose background and lifestyle were a classic placing of the magic lantern in the world of popular entertainment.

Mayhew's 'Old Street Showman', aged fifty-five, was a 'short, thick-set man with small puckered-up eyes and dressed in an old velveteen shooting jacket'. His father had served abroad as a soldier and thereby reduced his mother to the workhouse (before an uncle rescued her and set her to work as a washerwoman). As a child, the showman had served a seven-year apprenticeship as a climbing chimney sweep, often turning out at three or four in the morning, barefoot in the frost. Sometime during those black years his fellow-sweep, Dan Duff, died. Having served his term, the showman left his master, bought a set of pandean pipes and worked as an organ-grinder's mate, saving money to buy himself a drum. Then he worked with another showman, Michael ('an Italy man'); his bear, Jenny; his monkey, Billy (dressed like a soldier) and his two dancing dogs. The whole troupe was imprisoned for a weekend in the North, after the Chester races. On the orders of the Magistrate the bear was shot (and his skin sold to hairdressers!). Next the 'Old Showman' teamed up with another foreigner, 'named Green', who showed clockwork dancing figures. They included

Lady Catarina, a Turk called Bluebeard, a sailor and Neptune's (or Nelson's) car. For sixteen years they toured their show in the summer; in winter, however, they turned to the magic lantern to make a living.

> We showed it on a white sheet, or on the ceiling, big or little, in the houses of gentlefolk, and the schools where there was a breaking up. It was shown by way of a treat to the scholars. There was Harlequin and Billy Button, and such-like. We had ten and sixpence and fifteen shillings for each performance, and did very well indeed. I have that galantee* show now but it brings in very little.
>
> Green's dead, and all in the line's dead, but me. The galantee show don't answer, because magic lanterns are so cheap in the shops. When we started, magic lanterns wasn't so common; but we can't keep hold of a good thing in these times. It was a regular thing for Christmas once — the galantee show.[7]

Mayhew's showman laments the passing of the professional galantee man: but many of the street-folk Mayhew met indulged in the business-is-not-what-it-was line, hymning the good old days. In fact, the day of the lantern was only just beginning in the 1840s, with the birth of photography. The camera supplied infinite images to project — entertaining, beautiful and instructive. So the lantern increasingly became, as well as an entertaining toy, the agent of education, both moral and secular. The magic lantern could bring into the classroom an extra dimension of delight. Professor Pepper at the Polytechnic Institution in London's Regent Street, enthralled his young audiences by projecting 26-foot pictures of twitching frogs' legs in demonstrating the power of electricity.

But who first projected *photographs*? The Victorians laid various claims and the dispute punctuates journal correspondence columns. One claimant was a syndicate of northern scientists, Messrs. J. B. Dancer, J. Lancaster, W. Heywood and E. Hutchings, who first excited the incredulity of an audience in the Manchester Mechanics Institute in January 1854, with photographic slides remarkable in their sobriety — sculpture and architecture. With improvements to slides, lenses and lighting, the show became a regular seasonal attraction, edifying the audience and enriching the funds of the institute by some thousand pounds per year.[8] By 1857 slides of Francis Frith's Egyptian photographs were available to transport the audience from the Manchester rain to the middle-eastern sun. What

*In England, itinerant magic-lantern showmen called their entertainment the 'galantee show'; the phrase was a corruption of the garbled street cry 'galante so' (meaning 'fine show').

thrilled the audiences (brought up on a diet of crude caricature in slides) was the verisimilitude: 'What is more calculated to excite and keep awake the attention, even of the most uninformed, than a true transcript of nature, a faithful picture, which "nothing extenuates, nor sets down aught in malice", with every feature brought out into the most distinct and vivid relief?[9] How touching is this naive, early faith in the 'honesty' of the camera! The excitement is akin to our sitting agog watching TV pictures of a man stepping on to the surface of the moon.

There is great appeal in the idea of the Manchester of the 1850s as the birthplace of the photographic lantern slide. For a short while, at least, in 1857 the city became a cultural mecca (for over 1,300,000 people) in staging the first exhibition of paintings drawn from private collections, as an artistic sequel to the Great Exhibition of 1851. Among the visitors were the Queen, Prince Consort and the Prince of Wales. That exhibition saw the birth of an orchestra which outlasted the occasion and took on the name of its conductor — Charles Hallé. It would be apt to add the photographic lantern slide to the achievements of a decade which earned the city, despite its smoke and mud, the accolade of 'the very symbol of civilisation, foremost in the march of improvement, a grand incarnation of progress'.[10]

There are, however, two counterclaims from across the Atlantic and one has the advantage of flamboyant appendages. The greyer pretender is one Mr Ransom; he was reported in the *New York Times* towards the end of 1853 to have invented a means of projecting the Daguerrotype (the earliest true photograph, the image formed by mercury vapour on a polished coating of silver on a copper plate) on to a canvas, so that an artist could trace the outline of a 'perfect' portrait. Earlier still and more exciting is the invention of the Langenheim brothers of Philadelphia in 1849 of glass transparencies under the name of Hyalotypes. For the elder of the two brothers, Wilhelm, however, this represented a retreat into dullness: arriving from Germany in 1834, he served in the Texan War of Independence against Mexico, helped recapture the Alamo, was taken prisoner and condemned to death, escaped and fought against the Seminole Indians in Florida, before joining his brother, Friedrich, as mere photographer.

The invention of photographic lantern slides, with their accuracy, delicacy and definition, meant that the lantern was, for a time, not as good as the slides it projected — not able, that is, faithfully to transmit the quality of the image to the screen. The problem had nothing to do with the actual body of the lantern: its design was primarily a box to hold the light (with a chimney to expel the heat) a slide carrier and a lens. The choice of material for the lantern box was more a matter of appearance and expense than of

practicality. The cheapest (and, therefore, the commonest) lanterns were made of japanned tin; Russian iron (made in Birmingham) was preferable, less affected by the heat and less easily damaged by rough handling; but the Rolls Royce lanterns were made of mahogany (well-seasoned and lined with tin to withstand the heat) and decked out with brass fittings and ornamentation.

The lantern's limitations had nothing to do either with its optical components — except in the case of cheap lanterns fitted with lenses not corrected for two kinds of distortion called spherical and chromatic aberration.[11] The only other part of the optical system was the condenser (first used by J. T. Taylor in 1866), placed between the light source and the lens, to converge the light rays and ensure that they pass through the lens. The same basic optical system is still used in projectors today.

The weak link in the magic lantern throughout Victorian times without mains electricity was the light source; and one of the fascinating and slightly horrific aspects of the story of the lantern is the search for an illuminant which was at once safe, cheap and convenient.

Candle-power lanterns were already items of historical curiosity when photography was born. The standard form of illumination in the mid-nineteenth century (and long after for parlour exhibitions) was the oil lamp. There appeared on the market, for use in home entertainment, the 'lamposcope' — a simple magic lantern which took the place of the glass globe on the top of the standard paraffin lamp. The more sophisticated arrangement was to have a lantern body large enough to stand an oil lamp inside. The design and efficiency of oil lamps had already been much improved at the end of the eighteenth century: a Genevan, Amy Argand, discovered that the flame burned much more brightly and cleanly when, with the use of a circular wick and narrow-necked chimney to create a draught, air was drawn past both outside and inside the flame. The power of the standard 'Argand' lamp was measured at thirty candles.[12] The oil could be saturated with camphor to improve the flame.

The one major improvement to the Argand principle in oil lamps came from across the Atlantic. L. C. Marcy of Philadelphia intensified the light by straightening out the circular wick and placing two or more wicks side by side. His 'Sciopticon' lantern (its light measured at over forty candles) earned a British disciple in Walter B. Woodbury of Manchester,[13] who introduced it to the British market. Thereafter, it was much imitated — 'among others, we have had the euphaneron, the lucidus lantern, the eureka lantern, the excelsior lantern, Steward's lantern, Jones' lantern and, in fact, anybody's lantern who chooses to order a sufficient number, and have his own brass plate attached'.[14]

With all its improvements and modifications, however, the oil lamp could only produce a light which, by modern standards, was feeble — quite inadequate for public lantern exhibitions. One alternative source of light occupied the improvers of the magic lantern to the point of obsession; it gives us the deadest of all theatrical metaphors — 'limelight'. The use of limelight derives from a double invention and discovery: the invention of the oxy-hydrogen blow-pipe and Sir Humphrey Davy's subsequent discovery that lime, far from being melted by the oxy-hydrogen flame, emits an intense white light. In 1826, during the Ordnance of Ireland Survey, Lieutenant Drummond, R.E., demonstrated the power of this new limelight: his crude lamp (in Antrim) could be seen on Ben Lomond in Scotland, ninety-four miles away.

Limelight, however, could be lethal. The explosive potential of oxygen and hydrogen mixed is known to the most intransigently unscientific. The great problem for lantern designers and operators, therefore, was to keep the two gases apart before, during and after the show, except at the point of combustion. In practice (with the 'safety' or 'blow-through' jet as opposed to the more dangerous 'mixed' jet) the lanternist lit his hydrogen flame first and then allowed a fine stream of oxygen to play through it to impinge on the lime. In the early days the gases were carried often hundreds of miles by train, in cumbersome bags, made of two layers of stout twill with a rubber membrane in between. In use, the bags were trapped between boards and held down with huge weights (up to one hundredweight each) to produce the pressure. A standard six-cubic-feet bag measured three feet by two feet by two feet, and the lantern operator needed two of them — as well as the rest of his equipment. In all the various developments of limelight, oxygen remained the constant component, while other gases were tried with it in place of hydrogen: coal-gas, benzolene and ether.

Gas bags of oxygen and hydrogen with two half-hundred weight weights to create the pressure

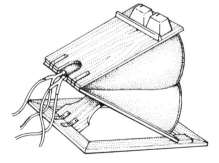

They all had their perils. Ether 'saturators', for example, had to be relied on to provide and regulate just sufficient vapour to form a combustible, rather than explosive, mixture with the oxygen. In 1897 the catastrophic

An ether saturator, marketed by the Rileys

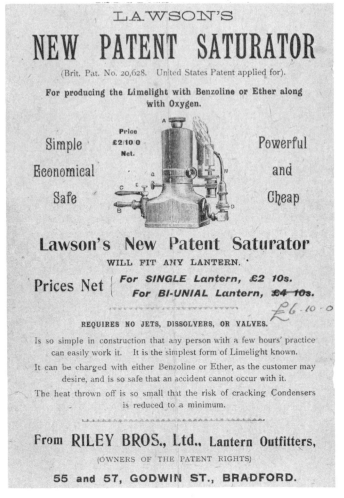

results of the wrong mixture were the deaths of nearly fifty people at the Paris bazaar, after an explosion and fire. The showman, who had casually placed a bottle containing several pints of ether close to his lantern, was sentenced to imprisonment and hard labour. Despite its cheapness, ether was then banned in both Paris and London.

In the 1880s cylinders of compressed gas were introduced in the place of the cumbersome bags, but the lantern showmen still presided over potentially lethal machinery. Gruesome accident reports punctuate the columns of the lantern journal. In January 1890, Bill Bow, foreman of the Scotch and Irish Oxygen Works at Rosehill, Glasgow, was removing cylinders (six feet by six inches and pressurised to 3,600 lbs, p.s.i.) from the

workshop into the yard, when one exploded. Bow was fatally injured — 'the lower part of his jaw was shattered and forced up into the brains, which were protruding'.[15] As if this deadpan piece of macabre were not enough to drive home the force of the explosion, the reporter added that fragments of the cylinder were found a quarter of a mile away from the site of the explosion, having penetrated several wooden fences en route. Worse, Bill Bow lived for two and a half hours after the accident. His 'sad and untimely end' was caused by inadvertently mixing hydrogen and oxygen in the same cylinder.

A few years later, a young lad in Bradford fell victim to the same ghastly error, when he dropped a cylinder in the subway of the railway station. Professor John Goodman of the Yorkshire College, Leeds, was baffled that the cylinder itself should have 'shattered to fragments like so much glass'. To allay the fears of those who found themselves seated near the lantern during exhibitions, Professor Goodwin inflicted on a similar cylinder the kind of violence inflicted on the can of peaches in *Three Men in a Boat*. He dropped the fully-charged cylinder 22 feet on to a block of cast iron; subjected it to internal pressure of 2 tons per square inch; dropped it again 22 feet, then twice over 50 feet (from the roof of the Engineering Department) on to a sharp cast-iron block. The resulting dents ranged from 'small' to 'indetectable'. Only after the cylinder had been squeezed almost flat in a hydraulic press did it puncture — 'but without dislodging a single loose fragment'. Professor Goodwin does add, however, that three deck-hands from Albany, New York, paid the penalty of manhandling cylinders too roughly — 'throwing them down in the warehouse'. An explosion blew off the legs of two of the men and rendered the third unrecognizable.[16]

British railway companies took fright at this carnage and prohibited gas cylinders from passenger trains. That decision tested lecturers' guile: they concealed their equipment in cricket bags, musical instrument cases, portmanteaux and brown-paper parcels. Well-known lantern lecturers were likely to be searched at the station; so they sent their gas (in disguise) in advance. The struggle between vigilance and ingenuity was finally resolved by the railway companies laying down stringent precautions for the transport of gas cylinders. No longer did passengers have to shrink suspiciously from strangers carrying elongated parcels.

Small wonder that the search continued for a safer and more convenient illuminant. After Willson discovered a means of commercially producing carbide from coke and lime, acetylene was precariously popular during the 1890s, though it exploded when compressed, or mixed with oxygen, and the carbide had to be kept absolutely dry. The unburnt vapour also gave off a sickening smell and the gas attacked the brass fittings of the magic lantern.

Some of the amateurs set about their experiments with acetylene with a casual abandon which suggests that they valued their lives at little. Vincent Hyder remembered procuring, with some difficulty, one pound of calcium carbide and putting a small piece in an old tin with some water and two pin holes in the lid. He then lit up. The result was 'a minor explosion and a surprising amount of flame'. So he graduated to larger drums but never produced more than a 'fair light and a lot of smoke'. Eventually, however, acetylene gave the death to oil lamps in the magic lantern.

Somewhere among this volcanic activity the electric arc lamp began to makes its way. It had actually been used as early as the 1860s,[17] though it was uncommon until houses were supplied with mains electricity.

However liable the magic lantern was to unscheduled pyrotechnics, its operators felt by 1890 that they had an instrument sophisticated enough not to be dismissed as a mere novelty. In March 1894, D. Noakes and Co. showed slides in the Albert Hall (in daylight) at the annual meeting of Dr Barnado's. Their lantern, with a 'throw' of 190 feet, produced a good 36-foot picture. Powerful and complex as his lantern might have been, the Victorian lecturer could never simply plug in and switch on. With the equipment he carried, he could have been mistaken for a mobile general store: lantern and rolling curtain, condensers and objectives, lengthening tubes, jets (and spares), dissolver, oxygen supply, hydrogen supply, stands for gas bottles, key wrench, pressure gauge, rubber tubing, hard limes, lime tongs, thumbscrew, elevator, slides (with templates and carriers), tinting glasses, opera glasses, screen, frame, rope, twine, eye screws, hammer, driving hooks, nails, gas pliers, wedges, white lead, matches, curtain for stand, reading lamp, signal, lecture, music, duster, wash-leather, file, knife, special articles . . .[18]

Not surprisingly, successful lanternists were anxious to impress on their public that their machine was no toy. Some (led by no less a person than W. B. Woodbury) objected to the epithet 'magic' applied to the lantern; to them it connoted mere bauble. Woodbury also disapproved of the classical pedigree of the American alternative, 'Stereoptikon'. Instead, he proposed the name 'Scioscope' as etymologically more pure.[19] This sibilant mouthful failed to catch on, but there were countless other attempts to oust 'magic'; Stereoptikon, Phantasmagoric, Sciopticon, Triplexicon, Dioptric, Binoptric, Biunial, Triunial, Photogenic, Pamphengos, Pantaphone, Aphengescope, Megascope, Euphaneron, Polyopticon, Bijou, Photinus, Cyclexicon, Heloscope, and many other trade names.[20] But the word 'magic' stuck, as if to preserve the sense of wonder felt by the audience. (David Livingstone claimed to have had an oil-burning lantern in Africa and described it as his 'most valuable travelling friend'. Whenever supplies

were low, he could rely on his lantern's 'magic' properties to evince gifts of food from the natives.)

A simple 'dissolving' mechanism

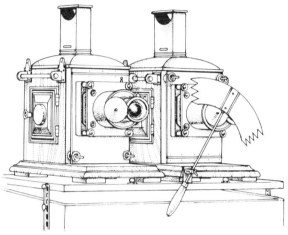

One effect which could indeed appear quite 'magic' was the 'dissolve'. In fact, 'dissolving views' became synonymous with 'lantern show'. The 'dissolve' referred to the skilful operator's ability to smooth out the transitions between the slides so that the audience were unaware that they were watching a series of separate entities. In the early days this required two lanterns focused on the same screen, but in the 1860s appeared the two-in-one (or 'biunial') lantern: literally two lanterns joined one on top of the other, two lenses and two lights. In 1874 J. H. Steward, a London optician and meteorologist for the British Journal of Photography, con-structed his 'triunial' 'Bridgman' lantern — a three-in-one giant. Thereafter the triple lantern became the *sine qua non* of the professional showman. There survives in the Science Museum in London a photograph of C. Goodwin Norton (author of *The Lantern and How to Use It*) dwarfed by his monster triple brass-and-mahogany lantern. To enhance the showman's sleight of hand in dissolving, various patented mechanisms appeared — the 'Metamorphoser', 'Beard's Eclipse' the 'Terpuoscope' and 'Lancaster's Shutter'. With accessories such as these, the showman could imperceptibly transform a monochrome vase of flowers into a fully-coloured bouquet or set fire to a building by subtly superimposing flames.

C. Goodwin Norton himself describes two of his startling effects. In the first, which required three lanterns, the Houses of Parliament were shown reflected by daylight in the River Thames; then the scene dissolved into night; the moon rose and the windows of the building lit up; clouds passed

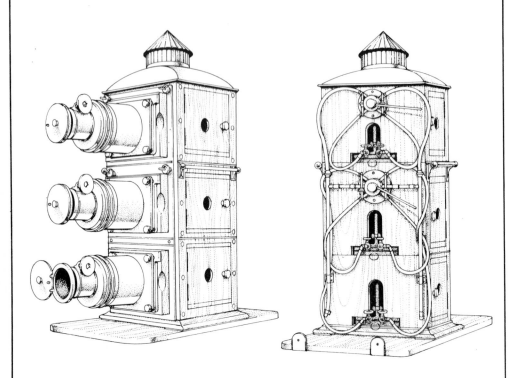

over the moon and the river below rippled. Norton could also add snowstorms to his winter scenes. This required a piece of calico (with pin holes in it to simulate the snow) wound round two rollers. The ingenuity required to work three lanterns at a time meant that mistakes were inevitable: 'any mistake such as winding the snow up instead of down should be immediately covered by the lecturer making some remark upon the erratic course of a snowstorm during an east wind in January, or something similar; as a rule, an apology only makes matters worse.'[21]

Such sentimental and melodramatic effects as Norton's were not new to audiences of other Victorian optical shows. The magic-lantern showmen vied with and sought to outdo their popular predecessors, the Panorama and the Diorama (and, indeed, a competing legion of -amas: Betaniorama, Cyclorama, Europerama, Cosmorama, Giorama, Pleorama, Kalorama, Kineorama, Myriorama, Poecilorama, Neorama, Nausarama, Octorama, Physiorama, Typorama, Valorama, Uranorama). Such a list is a tribute to the public demand for the display of large-scale coloured pictures, enhanced by lighting effects and, often, music.

C. Goodwin Norton

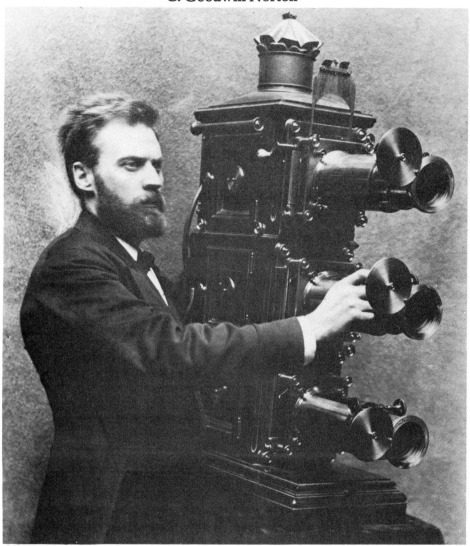

The invention of the Panorama illustrates (as does James Watts' steam engine) how great ideas emerge from trivial things. Robert Barker, an Edinburgh painter, imprisoned for debt around 1785, allowed light from the single grating in his cell to fall on the letter he was reading. He put this apparently banal, incarcerated experience to good use and, in 1792, he exhibited his first Panorama — a huge, concave picture, 16 feet high and 45 feet in diameter, skilfully lit from above and revolving slowly round the spectators in the middle. The first Diorama, based on the same principle of

illuminated painting, was actually built in Paris in 1822 by none other than Daguerre, though it was his later work in photography that assured his name's immortality. What makes the enormous labour of painting the pictures for these shows even more astonishing is the frequent choice of ephemeral subject. At Covent Garden there appeared the verbose *Moving Diorama of the Polar Expedition, being a series of views representing the progress of His Majesty's ships, the* Hecla *and the* Envy *in their endeavours to discover a North-West Passage from the Atlantic to the Pacific Ocean.* In 1812 a panorama in Berlin showed the burning of Moscow only three months after the event. More traditional artists sneered at the sensational effects: John Constable's response to Daguerre's Diorama (in London, 1823) mixes aesthetics and xenophobia in a way that makes it difficult to say where judgement ends and prejudice begins: 'It is without the pale of art, because its object is deception. The art pleases by reminding, not by deceiving. The place was filled with foreigners, and I seemed to be in a cage of magpies.'[22]

These popular entertainments found their way into the provinces. One famous touring Diorama, founded by the four Hamilton brothers in 1848, visited the Free Trade Hall, Manchester; the Coliseum, Leeds; and St George's Hall, Bradford. St George's Hall, built in 1851, just five years before William Riley was born, was to Bradford what the new Town Hall was to Leeds — a symbol of competitive Victorian civic pride. The corporation measured the stature of their hall literally in feet and inches, just as they weighed the value of the Mayor by the gold in his chain. (Samuel Smith, stuff-dyer and finisher, Mayor from 1851 to 1854 and the first to be elected three years in succession, wore a massive gold chain, costing £250 and weighing twenty nine and a half ounces.) St George's Hall was built to satisfy the needs of both merchants and concert-goers. To accommodate Hamilton's Diorama a great screen was stretched across the whole width of the stage. The young William Riley was unfailingly stunned by the annual show. The clever lighting effects were still clear in his mind eighty years later: 'A Swiss landscape would be shown: the background of mountains; the green fields in the valley; and the blue sky overhead — everything flooded with light. Then, as we watched, the shadows of evening spread over the scene; the sky became overcast and clouded; a full moon appeared and its reflections sparkled on the waters and silvered the landscape. There was, I remember, a representation of the city of San Francisco; then, suddenly, its destruction by earthquake. How these effects were produced I was never sufficiently interested to discover, but they thrilled and pleased us in those pre-cinema days.'[23] Hamilton's Diorama was not killed off by the lantern; it survived almost until the First World War when, in 1911, Victor Hamilton and his brother put their money into movies. One of the brothers

opened the 'Picturedrome' at a converted chapel in Bradford.

Through the Diorama and the Panorama, Victorian audiences developed a taste for colour in their picture shows. But photography was black-and-white until well into the twentieth century. To appease popular appetites, therefore, there grew up an industry of hand-colouring photographic lantern slides. The quality inevitably varied from miniature masterpieces to rough daubs; handbooks and patented methods of applying the paint to glass flooded the market. An early purist was A. H. Wall, insistent on the need for artistic colouring, 'so as to throw upon the screen pictures full of sentiment and poetry . . . and such as would be infinitely superior to the crudely gaudy slides now in common use'.[24] Wall suggested a first painting in water colour and a second in oil 'to obtain the richness, depth and brilliancy of colouring and force of effect'. Wall believed that a three-inch glass slide should be able to withstand critical attention enlarged to twenty or thirty feet.

For the large-scale slide manufacturers, however, commercial considerations demanded something far simpler for a less discriminating public eye. Manufacturers employed batteries of assistants to apply the colour. An advertisement for Walter Tyler's business in London's Waterloo Road shows a rigid production line in the 'slide-painting room'. (Walter Tyler started as an itinerant lantern showman; in 1885 he took a small shop in Waterloo Road; his premises quickly expanded to embrace nos. 48, 50 and 94 in one of the largest lantern businesses in London.) With more pretension to artistry, Chatham Pexton of Holloway seated his young ladies at easels in a 'studio'. He disclaimed any secrets or fanciful methods — 'we trust to skill alone'.[25] A reporter from the *British Journal of Photography* watched the painting of a sky: blue oil pigment mixed with varnish was applied from the top in broad sweeps from left to right, becoming lighter near the horizon; rose madder was added to bring the sky to the land 'in a warm and pleasant tone'. The actual blending of the colours ('with such

A slide-painter's easel

imperceptible grading as to present the appearance of one harmonious and continuous whole') was done simply with the finger. One assistant showed her skill by laying a broad tint on a piece of glass so uniformly that the paint appeared to have been poured over the surface. Then she transformed a monochrome Scottish coastal scene by draping it in moonlight.

The amateur at home, however, eager to colour his own slides, was reminded firmly of his proper place: 'Let the beginner not attempt sunsets of the gorgeous order, after the manner of G. M. W. Turner (deceased).'

Magic lantern shows were usually adorned, too, with the colours of rhetoric. The accompanying lecture was, as it were, the frame to the pictures. Some firms specialized in the production and sale of lantern readings. Invariably, they were long monuments to pedantry, moralizing and sentimentality, and those that survive are often overlaid with the frantic crossings out of lanternists desperate to retain the goodwill of their

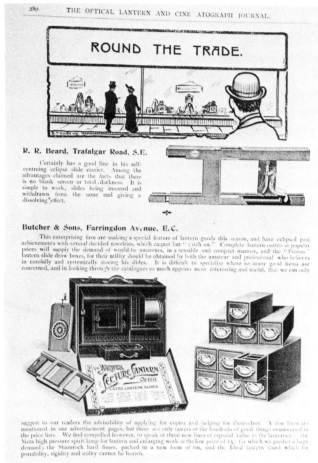

audiences. Those who failed ran the gauntlet of heckling and even physical assault: T. C. Hepworth remembered being peppered with missiles from pea-shooters.[26] The Reverend Wm. H. Young, Ph.D., writing earnestly in the *Optical Magic Lantern Journal Almanac* with all the devices of classical 'High Style', admonished the lanternist: 'Pictures that talk, not lecturers is what people value. Lectures are silvern but slides are golden.'[27] The Reverend Young then developed a metaphor quite bizarre in its complexity to argue that lecturers should sugar their pill and teach by delighting. He recognized an important fact — that Victorian magic lantern shows touched the heartstrings of ordinary people. The Church saw that and enlisted the help of the magic lantern as an agent of salvation. Nothing else could quite have guaranteed the lantern's respectability, rescuing it from among the freaks and follies of the fair.

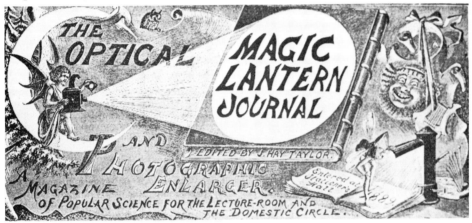

As if to herald this new heyday of the magic lantern there appeared in 1889 the specialist journal, *The Optical Magic Lantern and Photographic Enlarger*, founded by J. Hay Taylor, son of J. Traill Taylor, then editor of the long-established and respected *British Journal of Photography*. Some contributors to the new magazine had enough experience to look back nostalgically to the days when lanterns were *really* lanterns. George H. Slight (lantern operator for the Edinburgh Photographic Society for over thirty years) recalled with pride showing in Glasgow City Hall in the early 1860s slides of the great pyramids, using a lantern with a 90-foot 'throw' on to a 25-foot screen. This required an enlargement of some 600 diameters from the original 1-inch-square negatives, as if turning a pin head into a tractor wheel. With an old-timer's pride, George Slight questions whether such phenomenal definition was still possible in these 'modern' times. He concludes, with affected understatement: 'I do not think old-fashioned lanternists have anything to be ashamed of in the results they obtained.'[28]

For a long time following the discovery of their lantern slides, the Rileys themselves remained vague silhouettes, their story only a suggestive outline. No research into the history of the magic lantern brought the Rileys any closer. Then, suddenly, after two years of my simply waiting, the family came alive, and 'Riley Brothers Limited' became an episode in an evocative family saga.

I had been lecturing to a small group about an earlier venture of mine into the glassy-eyed world of Victorian photographs when one of the audience asked the inevitable, 'What next?'. Briefly I outlined the story of the Bradford lantern-slide makers, as far as I knew it at the time, but without mentioning any names. A surprised voice asked whether I was talking about the Rileys: 'William Riley was one of my father's best friends.'

The connection turned out to be interesting but tenuous. However, it did put me in touch with the most eloquent authority on the Riley family story — William's own autobiography, *Sunset Reflections*.

Written in William's ninety-first year, the book is a remarkable document, if somewhat rambling and sententious. Nearly half a century after the end of the lantern-slide business, William Riley surveys through his own and his father's eyes, over 120 years of family history, beginning in the year after the accession of Queen Victoria, when his father was born. *Sunset Reflections* chronicles the dawn and midday of a self-made Victorian family.

Joseph Riley, William's father, was born into a Bradford where tar-barrels stood in the streets to combat cholera.[29] More precisely, Joseph's home was on Bradford Moor, detached but single-storeyed and within a garden full of pigs and poultry, 'in a little colony of humble dwellings with a few mean-looking shops'.[30] Joseph was born the fifth child of a hand-woolcomber, earning 15/- per week; his wife earned 18d per day as a part-time 'char'. As each child reached the age of eight, he was sent to work twelve to fourteen hours a day, on a regularly thin diet of porridge, potatoes and turnips, boiled with bones. Joseph Riley actually started work at the age of seven for a shilling a week, earned as assistant to a man who twisted hemp into rope. At the age of nine he opted for the lesser rigours of coal-mining.

From these incredibly but characteristically harsh beginnings two institutions, both classically part of the world of Victorian self-help, pushed Joseph Riley to success: the Mechanics Institute taught him to read and write; Wesleyan Methodism brought him the fruits of inspired self-discipline — and a troublesome conscience. As a successful lay preacher, Joseph was encouraged to think in terms of a call to the ministry; when he turned it down in favour of marriage, he was warned by an outraged minister that his future prosperity would be hampered by the Almighty's displeasure. Thereafter, Joseph always attributed his misfortune (including the troubles and final collapse of the lantern-slide business) to divine retribution.

Oddly, he did not see it as part of the Almighty's revenge when, after only a few years of marriage, his wife died in childbirth, while suffering from smallpox. She had, however, already borne two healthy sons — Herbert (b. 1863) and William (b. 1866). Mother and still-born third son were buried on William's second birthday.

Of his childhood William remembered an insanitary city where Forster Square was still 'congeries of dim and dirty alleys'[31] and where the stream from which Bradford drew its name 'ran uncovered through the town, filthy beyond belief'[32] with a terrible stench. The odour also reached the nostrils of the Board of Surveyors, appointed in 1863. They commented in unlovely detail on the 'noxious compound' flowing through the sluice from the city drains to the canal, where it was made even more offensive by being heated up in the factories drawing canal water through their boilers. Occasionally, the canal even 'took fire'; it earned its nickname, 'River Stink'. At least the new corporation (Bradford became a borough in 1847) struggled to prove the truth of its new motto, *Labor omnia vincit* ('Work conquers all things'), trying to resolve the urban chaos of a population which had grown at least fifty per cent in *each* decade from 1811 to 1851. After the Improvement Act of 1850 a metaphorical new broom swept clean the city centre. And, three miles to the North, Titus Salt (Mayor in 1848) was completing his new model factory and laying the foundations for the new town of Saltaire.

William Riley's childhood, too, had its lighter side. He remembered the generosity of his elder brother, Herbert, who was even prepared to swallow his medicines for him when he was ill. The family doctor may have shared the joke: he was a humorist, too — with a talking parrot concealed in his surgery to confuse and embarrass the patients.

Meanwhile, Joseph Riley, the father, had set himself up independently as stuff merchant. He had long before emerged from the coal mines and had served variously as printer's apprentice, book-keeper in a mill and manager

in his father-in-law's business. This last arrangement came to an end and precipitated Joseph's independent career when he decided to remarry. His choice, as his sister-in-law tediously reiterated, was a 'man' — Mary Elizabeth Mann, daughter of a Birstall chemist, and a cultured and educated lady. In time she bore Joseph another seven children, though she also treated her stepsons, Herbert and William, as if they were her own.

The family's increasing size and refinement demanded the services of a maid, at once practical necessity and index of their new-found social status. In response to his parents' advertisement, William Riley applied for the job himself in the guise of a woman, answered the questions demurely and was offered the job, before his joke was exposed. His more serious aspirations, however, were boosted by his parents' expensive decision to send him to Bradford Grammar School, already a notable institution of three hundred years standing. There William and Herbert Riley rubbed shoulders with very able pupils who later became famous, such as Frederick Delius, Frank Dyson, William Rothenstein and Cutliffe Hyne. But William made no friends among these or, more generally, in the school. The place served only to remind him that he was in a social sense out of his class. Many of the school's three hundred scholars were the sons of wealthy Jewish and German industrialists from much smarter parts of the city. They would not pass through Frizinghall, where the Rileys lived, except en route to the Dales or the North.

During their teens Herbert and William Riley showed flashes of that rash entrepreneurial impulse that later was to make and mar Riley fortunes. At the ages of nineteen and sixteen, and under the spell of *The Boys Own Paper*, they produced a lithographed magazine called *The Frizinghall Naturalist*. For William the science was mere pretext to get into print. As illustrator, he foisted unnatural monsters on to credulous readers. After an early success, the brothers moved to letterpress printing before the whole project collapsed and their father was left to clear a debt of some £20. Further afield, the boys explored by bicycle and by train. Two wheels (the 'safety' bicycle was by now a common sight) took them to the new Saltaire (for boating on the Aire) and to Shipley Glen. The Midland Railway took them to Harrogate and Knaresborough, Ilkley and Bolton Abbey, Skipton and Haworth.

The Rileys' love of the Dales was surpassed only by their attachment to Methodism. Influenced by their parents — especially their mother (though she had actually been brought up an Anglican) — the children in turn made public ackowledgement of their faith. William's 'conversion' seems to have been a level-headed affair: 'If it was conversion, it was not of the violent kind. There was no feeling of ecstasy, no breaking of chains or sense of

liberation from servitude to the devil, no passionate emotion.'[33] Thereafter, however, William was as irrationally predisposed as his father to see the hand of God in his affairs. And at the end of his life, prompted to ask (in his autobiography) 'Who Has Done It?', William quoted Shakespeare, Voltaire, Hugh Walpole, Tennyson and the modern unleashing of powers (Electricity, X-rays, Wireless, Television and Atomic Energy) as evidence of that 'someone who really cares for us and will see that we get what is best for us'.[34]

Divine Providence or not, the Rileys' stuff business prospered and the family increased (to eight children). The one made it necessary, the other made it possible to move to a much larger house: a semi-detached villa perched on the hill at 3, Moorlands Avenue, Baildon, some four miles north of Bradford. The one-storeyed wing of the house, previously used as a billiard room, served now as recreation room for the children. It was in this room, among children's toys, that the lantern-slide business was born in a way which suggests that, if God was determined that the Rileys should make a fortune, His ways were inscrutable.

Among the toys which littered the ex-billiard-room floor was a new magic lantern which Joseph Riley had bought for his two eldest sons, Herbert and William. It was impossible, however, to think of the magic lantern any more as a child's toy. It had (in the words of William Riley a few years later) 'passed a long, half-tolerated infancy of dirt and smoke and smell' to face 'a future of almost boundless possibilities'.[35] Joseph Riley took up the challenge: it occurred to him that, with himself cast in the role of lecturer and his sons working the lantern, they might give public shows and raise enough money to keep a child for a year in Dr Stephenson's 'National Home and Orphanage for Children'. So for two winter seasons Saturdays were given over to the lantern, until, inundated with bookings and requests for loan of his lantern from churches, schools and societies, Joseph realized that what had started as philanthropic gesture could become lucrative enterprise.

In deciding to set up a lantern-slide business, Joseph may have been prompted in part by the knowledge that William, having left school and joined him, was a reluctant passenger. Parts of the stuff warehouse were, therefore, converted into a shop and storeroom for slides (for sale or hire). William threw himself into the new venture with the zeal of a young man given a challenging opportunity, instead of occupying a predetermined niche in the shadow of his father. The immediate success of the lantern slides amazed everyone, including William: 'My entire outlook on the future had been changed without any intervention of my own. Life was no longer monotonously drab; the outlook was no longer bleak and

uninspiring. A job had been given to me that called for initiative and enterprise beyond my father's reach, but which I was confident was not beyond mine.'[36]

William's confidence was soon vindicated. Very quickly the lantern-slide business proved a cuckoo in the nest at Tyrrel Street and had to be moved elsewhere — to Godwin Chambers. Here a limited company was established with William in charge. In the early days, in the Baildon house 'playroom', the Rileys had bought uncoloured slides, although even William experimented by colouring them by hand. There were several do-it-yourself kits of translucent pigments and wedge-shaped brushes available to the enthusiastic amateur for around thirty shillings. At Godwin Street, in the new premises, William Riley was equipped to make his own slides, with photographic darkrooms and a glass studio on the roof. The colouring of the slides was handed over to a 'lady artist' while William wielded brushes in rather larger strokes — painting backclothes for studio slides.

The scale of the Riley's new enterprise is suggested by their bulky catalogue, of over 300 pages, published at the turn of the century. It advertised over 1,500 sets of slides for sale or for hire. Titles on offer range from the *Afghan Frontier* to *The Zuyder Zee*; from pseudo-scientific (*Phrenological Groups*) to comic (*Professor Feeler and the Bumps*); from Temperance (*Beware: or The Effects of Gambling*) to unashamed indulgence (*Home; Sweet Home*); from *The Life of Luther* to *Life of a Gnat*. Occasionally the catalogue throws up bizarre juxtapositions: *Wreath Mottoes* next to *Worms and their Work*. The slides were loaned 'at customer's risk' at a rate of 3s for 50 slides (4s for 'guaranteed coloured'); or, 'at our risk and carriage both ways', 5s 5d for 50 slides (6s 5d for 'guaranteed coloured'). Readings were lent free or could be bought, for about 6d.

Riley Brothers' catalogue also advertised their lanterns. They offered two main lines, backed by conflicting superlatives: the improved 'Praestantia', fitted for oil (at 4 guineas, 'the best, brightest and cheapest lantern in the world') and the 'Monarch Ethopticon Biunial', fitted with Lawson Patent Ether Saturator for limelight (at £22, also the 'best and brightest in existence').

To market the goods, William was joined by two of his brothers: Arnold and, somewhat reluctantly, the impulsively active Bernard. Routine bookwork of any kind was not his forte and he satisfied his more quixotic spirit by enlisting at the same time in the local Volunteers. Bernard shared with his father this quality of needing at least a glimpse of insecurity to give spice to his life.

Within a short time the Rileys felt they could claim to be 'The Largest

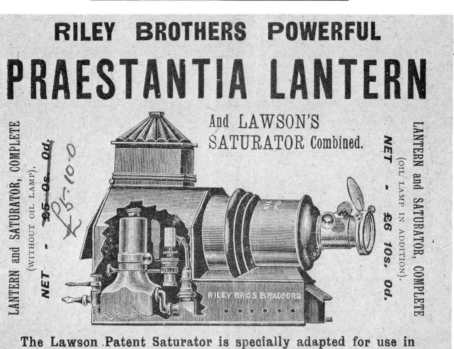

Lantern Outfitters in the World', though theirs was a business where hyperbole was common and several other rival firms made roughly the same boast. Rileys did, nevertheless, quickly become internationally known; their name crossed the Atlantic to the States, where a retired clergyman took up the cause as if it were divine. Swept along by this reverend zeal, Joseph Riley secured a huge overdraft by converting the bank manager, appointed half-a-dozen disciples in the USA and, in response to early orders, shipped across the mountain of goods on credit. Thereafter, the Stateside business was conducted more in promises than in cash by a New York agent who made up in optimism what he lacked in business acumen. What was needed to secure payment of the outstanding credit was more a Jaggers than a Micawber. The only man available to play such a role was the eldest son, Herbert, who, although trained in textiles, knew the warp and the weft of business matters. In 1894 Herbert, his wife and two children emigrated to New York. There Herbert found himself head of a far-flung empire whose territories had been conquered with no thought for their maintenance or lines of supply. Although the Riley Brothers' US business survived (in much contracted form) until Herbert's death, he

could not prevent the huge initial losses, which largely offset the successes at home.

Meanwhile, William Riley sensed the importance for the firm of the new 'Moving Pictures'. He attended the first public display in Paris in 1895 and found it 'thrilling' and 'miraculous'. Excited by the 'marvellous possibilities' William then returned to Bradford 'to interest myself in the production of a similar apparatus'. Thus far his autobiography confirms the popular story of the Rileys' involvement with movies; but William continues: 'Ten years, however, were to elapse before "Picture Houses" were opened in this country, and with that form of enterprise I was never associated.'[37] It is a matter of fact that Rileys and Bamforths (of Holmfirth) made films between 1897 and 1900. Why does William not mention them at all, even if it were Arnold or Bernard who dabbled in film? This was certainly a tide in their affairs which the Rileys seemed to catch and then miss; if the result of their abandoning movies was not wholly 'miseries', it was surely reason for everlasting regret.

In the event, it was not the cinema that killed off the Rileys but two sets of political troubles – the first from a distant and improbable source. To say that the Sultan of Turkey curtailed a lantern-slide business in Bradford would, on the face of it, be like saying that an eclipse of Uranus affected sales of plain chocolate. But the Rileys' textile and lantern-slide businesses were financially interdependent, both founded on Joseph's capital; and the textile business was conducted almost entirely with Greece, Turkey and Armenia. At the end of the last century the Near East was hardly a reliable source of trade: the massacre of 80,000 Armenians under Turkish rule between 1895 and 1898 (atrocity enough to bring Gladstone out of retirement to denounce it) obliterated Joseph Riley's main business network and forced him to write off all outstanding debts. Since British influence at Constantinople had evaporated, there was little chance of protecting British interests, especially as Turkey came increasingly under the wing of Germany and a German emperor who proclaimed himself protector of Mohammedans throughout the world — irrespective of whether they were de facto subjects of Britain, France or anyone else. Further Balkan disruption compounded the Riley's problems — especially, the short-lived, futile war launched by Greece against Turkey in 1897. For a time the Rileys were buffered against the full commercial impact of these upheavals by huge bank overdrafts; but the spectre of bankruptcy loomed over them.

It is a measure of the scale of the disaster for Joseph Riley that, before the political troubles, he had in the few years of running the stuff business, accumulated a capital of some £20,000, comparatively a fortune, but not enough to shield him. The inevitable blow came in August 1902, and

Joseph was adjudged bankrupt — an event of moment enough to make local newspaper headlines, though no one impugned Joseph's honesty. For Joseph the stigma of such publicity was easier to bear than his certain belief that the hand of the Almighty lay behind the catastrophe, punishing him for refusing the call to the Methodist ministry. Joseph lived with this fatalistic conviction for another twenty-four years and carried it to the grave in February 1926, at the age of eighty-eight. In the interim, he suffered further proof of the Almighty's displeasure in the death of his wife from cancer in 1910.

Fortunately, the lantern-slide business partially survived Joseph's bankruptcy, though for William it was thereafter only a clipped-wing performance. After his 'unfortunate experience' in the United States, his father had played no active part in the business, allowing William autonomy, while retaining a 'sleeping' place on the board. After the bankruptcy, Joseph's bank-manager usurped this seat and quickly proved that he was determined to be fully awake. Predictably, he tightened the purse strings and, although a novice in the business, suggested impracticable new schemes. William dismissed him as 'never more than a nuisance' and grew accustomed to driving the vehicle with the hand-brake applied. On his own testimony, business still 'prospered'.

It must, however, have been an odd time, for the lantern-slide business was a 'survival' in a second sense, looking increasingly anachronistic in a world of mechanized transport and an invention that was to revolutionize popular entertainment — moving pictures. In fact, cinematograph reels had been turning before even the first Riley Brothers' slide was offered for sale. In the same year that Joseph Riley set up his son in business, another young man, born in Brittany of English/Scottish parents and now working in laboratories in West Orange, New Jersey, was asked by his employer to grapple with the problem of producing 'moving pictures'. The young man's solution, the first really practical one, reached in 1892, took the form of a two-fold invention of camera ('Kinetograph') and peep-show viewer ('Kinetoscope'), which must be regarded as the true beginning of the cinema. Unfortunately for their lengthily-named inventor (William Kennedy-Laurie Dickson), the machines and their subsequent world-wide fame, carried the name of his employer, Thomas Alva Edison, who thus came to be credited as the man who did for the eye what his earlier Phonograph had done for the ear.

Edison's contraption took some time to cross the Atlantic; but England had its own champion already — William Friese-Greene, venerated in the 1890s but since then dismissed as a man of impracticable schemes. Friese-Greene's brightest idea caused a stir in 1889: on 5 November the *Optical*

Magic Lantern Journal carried a notice of his 'peculiar kind of camera' and 'lantern of peculiar construction' designed to present a 'startling optical novelty': 'It would doubtless seem strange if upon a screen a portrait [head] of a person were projected, and this picture slowly became an animated character, opened its mouth and began to talk, accompanied by an ever-changing countenance, including the formation of the mouth as each peculiar sound is uttered . . .' Clearly an idea difficult to accept; but, within a few months, the wraps came off Friese-Green's 'Photoramic' machine. There is some doubt as to whether it actually worked.

Not all magic-lantern operators welcomed the usurper. Their own skill in 'dissolving' slides was hard-earned through experience and some of them understandably felt piqued at being supplanted by an automaton, like skilled arithmeticians who feel threatened by calculators: 'the animated photographs I put down as a mechanical triumph and the success of dissolving views to the skill of the operator'.[38] Lanternists, indeed, had good reason to be proud of their skill in 'dissolving' but their attempts at presenting 'moving' pictures were, by comparison with the real thing, crippled, albeit remarkable in ingenuity. The various types of mechanical lantern slides (slipping, lever, pulley and rackwork slides) could, between them or in combination, convince an audience that they were watching a mill wheel in rotation, a caricature rolling his eyes, a factory engulfed in smoke and flames or even a ship sinking in a thunderstorm. But the movement was restricted by the mechanical complexity of the single slide.[39]

The real precursors of moving pictures were not these mechanical lantern slides but a whole range of toys throughout the nineteenth century whose effect depended on the well-known phenomenon of 'persistence of vision' — that is, the momentary retention of an image on the retina of the eye, sufficient for it to be confused or combined with a second and later image.

As children we have all played with discs spun on string, with two pictures, one on each side of the disc, forming a composite image when the disc is spun fast enough. So the dog could be made to jump through the hoop, or the bird to sit in its cage, or the man to swallow the fish. Henry Mayhew[40] described similar 'Optical and Magical Delusions' offered on the streets of London around 1850. By spinning engraved pictures, pasted back to back on thin card, the fat man could be made to kiss the plain lady ('O what joy when our lips shall meet!'), the bespectacled cat blended into the dog with hat, wig and cane ('Cat-egorical' and 'Dog-matical') and the austere lady embraced her husband with the big beak ('Cross-purposes'). These cheap tricks were the lower end of a market which ran to very sophisticated

effects. Many of the more elaborate toys made their debut at the Royal Polytechnic Institution (closed about 1890). Mr Childe's 'Zoetrope or Wheel of Life', elaborately painted on two four-foot wooden discs, showed a countryman open his mouth and swallow a jumping frog. Joseph Plateau, a Belgian, who in a tragic irony eventually blinded himself in his life-long study of optics, adapted the effects in his 'Phenakistoscope' for projection on to a screen. The most successful of these machines was Beale's 'Choreutoscope', which could represent figures in 'ten distinct and different attitudes with a clearness and rapidity of movement previously unobtainable'.[41]

Of course, the 'ten distinct and different attitudes' had to comprise *natural* movement. The remarkable work of one English-born photographer in the 1870s and 1880s made it possible to analyse animal movement in a way that had not previously been possible. Edward Muybridge (real name, James Edward Muggeridge) used batteries of up to forty cameras, triggered off by the moving subject being photographed, to show, for example, that all four feet of a horse are clear of the ground at moments in its gallop. Later Muybridge projected sequences of his pictures of horses (and others) through his 'Zoogyroscope' (basically a glass disc whose perimeter revolved at speed in a magic lantern). The effect was considered by some to be almost *la même chose*: 'So admirable an imitation of the real-life horse that nothing but the clatter of hooves and the breath of the nostrils is wanted to render the delusion complete.'[42] Thomas Edison, or, more properly, his employee, simply hit upon the idea of arranging an infinitely larger number of photographs than had previously been used on to a long strip which was passed at speed through a viewer — the 'Kinetoscope'.

Edison's 'Kinetoscope' had a mixed reception. News of the invention crossed the Atlantic before the machine itself and the rumours stretched the credulity of more than one commentator: 'It is said that Mr Edison has completed his 'Kinetoscope', about which various absurd reports have been current during the past year.'[43] The Kinetoscope's English debut at 70 Oxford Street, London, on 17 October 1894, attracted less than ecstatic notices and merited an understated mention in *The Times*, whose correspondent, in a classic litotes, referred to the Kinetoscope as 'not the least remarkable of Mr Edison's inventions'.[44]

Others, however, sensed the lucrative potential of this new diversion — among them two piratical Greeks, George Georgiadis and George Trajedes, who, resenting the cost (300 dollars) and short supply of Edison's machines, commissioned a London electrical engineer, Robert W. 'Daddy' Paul, to manufacture duplicates. Discovering that, by an amazing oversight, Edison had not patented his machine in the UK, Paul blithely

manufactured over sixty Kinetoscopes before the end of 1895. Paul's enterprise did not stop at the role of supplier: his kinetoscopes were empty vessels without films and Edison's films were protected by copyright, available only for use with genuine Kinetoscopes. Paul's solution to this problem has the air of al factotum about it: he invented his own camera, with the aid of professional photographer, Birt Acres, by March 1895, and made his own films, including brief, forty-foot records of the Derby and the Oxford and Cambridge boat-race. In the following year, Paul's former collaborator, Birt Acres, acquired transient notoriety by 'gate-crashing' the Cardiff Exhibition of Industry and the Arts (in June 1896) with a concealed camera, and catching on film the Prince of Wales scratching his head. That such a breach of regal demeanour should be preserved for public exhibition struck the more reactionary as obscene; Acres tried to explain away the Prince's gesture euphemistically as 'an elementary placing of the hand to the ear, probably to brush away an intrusive fly'.[45]

Nothing quite caught and stimulated public interest in moving pictures so much as the Cinématographe-Lumière. This machine, invented by the brothers Auguste and Louis Lumière (who recognized the limitations of the peep-show Kinetoscope), actually projected the moving pictures on to a screen, as well as acting as camera and printer. The first demonstration, therefore, which William Riley attended in Paris, could lay claim to be the first real 'film-show'. It was brought to London in February 1896, by Felicien Trewey, whose manual dexterity had already earned him international repute as 'shadowgrapher' — an art which every schoolboy instinctively practises when caught in a projector beam by forming silhouettes of rabbits and butterflies. Trewey's 'cinematographe' show opened for a season at the Marlborough Hall, Regent Street, on 20 February 1896, and the response of those who flocked to see it there (or transferred to the Empire Theatre, Leicester Square) suggests that the new toy had 'arrived':

> People move about, enter and disappear, gesticulate, laugh, smoke, eat, drink and perform the most ordinary actions with a fidelity to life that leads one to doubt the evidence of one's senses . . . The illusion was so perfect that one felt like pinching oneself or a neighbour to be sure one was not dreaming, but awake, and actually gazing on a mere photo-graph . . . Discoveries are thick upon us, from the Invisible to the North Pole, but in this we have one by far more immediately interesting.[46]

It was no dream; illusion, perhaps, but its impact was far-reaching. The Lumière films toured the country triumphantly and came within easy reach of the Rileys in Bradford. The films were screened in Manchester's Free Trade Hall in May 1896, and, later in the same year, the famous Lumière

train entered its station at 'Rowley's Empire', Huddersfield. It is an odd coincidence that the official programme for the first Cinématographe-Lumière in London was printed by a commercial neighbour of the Rileys — F. S. Toothill at 71 Godwin Street, Bradford.

The Rileys had no need of such incidental reminders of the approach of a competitor: there was ubiquitous evidence in Bradford. Cecil Wray of 2 Southbrook Terrace, demonstrated his own 'Kineoptoscope' projector to the members of the Bradford Photographic Society on Monday, 7 December 1896. The event attracted national attention: 'Some of the subjects were as good as anything yet shown in London or the provinces. *Eating Water Melons for a Wager* was highly effective and amusing; also *The Kiss!*'[47] Thereafter the Rileys acquired the patent rights and manufactured Wray's machine.

Within two or three years local enterprise expanded the film shows available in Bradford. In 1900 Henry Hibbert, a Bradford fishmonger and later Fellow of the Royal Photographic Society, showed imported films of the Boer War at the Co-operative Hall, Bingley and, in 1902, with co-fishmonger, Sunderland, Hibbert set up film matinées in Bradford's St George's Hall.

Twenty years before these developments, before even Edison filed his American patent or the Rileys sold a lantern slide, a pioneer in movies had set up his camera within ten miles of Bradford. Louis Aimé Le Prince (who was later to disappear sensationally in 1890 after boarding a train in Dijon) took moving pictures of pedestrians and horse-drawn carriages from Leeds Bridge in 1888. He showed the results privately to friends in his studio on Woodhouse Lane.[48]

While the Rileys made lantern slides, sound, too, of a kind, came to the cinema in the form of synchronized gramophone records. In February 1902, at the Festival Concert Rooms in York, the audience saw Miss Vesta Tilley mouthing *The Midnight Sun* to hissing and crackling accompaniment, followed by Mr Alec Hurley with the *Lambeth Cake Walk* and Miss Lil Hawthorne with *Kitty Malone*. The contraption was named — with a title almost breaking up under the weight of neo-technology — the 'Ciné-Phono-Motograph'. Appropriately, perhaps, the ensuing variety acts included a ventriloquist and contortionist.

The possibilities suggested by film to fertile minds were endless and bizarre. Patent records of the time are littered with schemes which foundered on the rocks of practicability. In October 1895, R. W. Paul (who pirated Edison's machine) devised and patented the idea of a multi-sensuous presentation of H. G. Wells' newly-published *The Time Machine*. If Paul had had his way, the audience would have been plunged

into darkness, rocked in their seats, subjected to blasts of wailing wind and astounded by fantastic projected pictures. Just occasionally, in these patents, are the germs of ideas which lay dormant for decades until technology made them less cumbersome. J. Grave's idea for 'colour music' is on display in all modern discotheques, though his suggested mechanism was more primitive: 'Notes from an ordinary piece of music are played on a keyboard whose keys are connected by cords or otherwise with shutters in an opaque slide which is placed in a magic lantern. Each shutter, when opened, projects a different colour on a screen and the notes of the music are thus rendered in colours.'[49]

William Riley himself indulged an inventive streak and took out several patents with no relevance to the magic lantern. One referred to a contraption for bicycles; another became a useful sideline for the family business and an anomalous piece of diversification. Through Department 'T', Riley Brothers sold 'Home Bath Cabinets — Russian or Turkish', priced at thirty shillings. The model in the catalogue is devastatingly simple — a large, openable, square box contains a bentwood chair and paraffin (?) heater. Of its efficacy the Rileys were equally devastatingly confident: 'Recommended by medical men everywhere for the CERTAIN cure of rheumatism, gout, lumbago, eczema.' Sir John Fyfe, M.D., added diseases of the liver and kidneys, and gallstones as inevitable victims of the Rileys' vapour bath; while a Dr Brereton verged on the all-embracing: 'It has become a question not what the vapour bath will, but what it will not cure.'[50] A typical advertisement is shown on page 49.

This atmosphere of excitement, enterprise and experiment came temporarily to a halt in 1914, and the new child, moving pictures, was, if not exactly killed in infancy, at least severely retarded by the exigencies of the First World War. Celluloid, used also in the making of high explosives, was in short supply to film-makers — and, indeed, to photographers of all kinds. Riley Brothers had to face the same shortage. What scuttled their ship, however, was not shortage of material.

When the lights went out in Europe in August 1914, the Rileys, having been sure that war would be averted, settled for the conviction that such rashness from the Kaiser would meet with swift retribution. When news of the outbreak of war reached William Riley en route from a holiday in Aberdovey, he probably basked in the prospect of a new line of business; the Riley catalogue soon advertised 'exciting pictures from Germany as soon as was practicable'. But within a few months the war was to put out the lights behind the lantern slides. First, Bernard, the youngest of the three brothers in the business, joined up immediately war was declared and was despatched to Belgium as sergeant in the 6th West Yorkshire Volunteers. Arnold and William were both too old for military service but one by one the rest of Riley Brothers staff, men and women alike, were drawn into the war. The two brothers, left alone, found they could more than cope with the work: soon after the outbreak of war, orders for their lantern slides dropped almost to nothing. The company was wound up.

Bernard Riley did not survive the war. He was mentioned in dispatches and awarded the Military Cross but was fatally wounded as the war neared its end. Arnold decided to take over the lantern-slide stock and make a go of it himself. In smaller premises, and with a limited horizon, he did make a living from the renamed 'Riley Brothers (1914) Limited' but it was a dim shadow compared to the bright lights before the war. Scattered references in street directories of the next decade or so suggest that Arnold also tried his hand at other things and even showed the initiative on which the Rileys had founded their brief fortune. In 1927 Arnold is recorded as 'grocer' and in 1928 there is a single tantalizing reference to 'Riley and Riley, Wireless Dealers'. Though he missed out on the movies, Arnold seemed to sense the importance of this new-fangled 'wireless', but his venture came to nothing. He did not repeat father Joseph's success.

William Riley was, however, in no sense a casualty of the war. With the winding-up of the lantern-slide business, William, on his own profession the 'lynch-pin', might well have faced a crisis. His capital had gone with the lantern slides; he was still young enough, at forty-eight, to need a new career, but too old and inexperienced, it seemed, to try a new line. By an

uncanny coincidence, however, a door had already opened on to a new prospect, as different from lantern slides as they were from textiles: in 1912 William Riley published a best-selling novel.

Put baldly like that, the event sounds remarkable enough but the story behind the book bears retelling even more than the story in the book. *Windyridge*, as William Riley's novel was called, is, in its casual beginnings, sibling to Mary Shelley's *Frankenstein* and Lewis Carroll's *Alice*. Where Mary Shelley staved off ennui among her companions on the shores of Lake Geneva in the summer of 1816, and where Lewis Carroll entertained three Oxford girls as they drifted along the Thames by boat, William Riley invented his narrative to console two sisters in Manningham, Bradford, after the death of their parents and 'more delicate' sister: 'It was when the short days of winter came along that the emptiness of the home became more keenly realised; one evening when the few of us were gathered round the fire, I said, "I tell you what I'll do, I'll write a story and read you each chapter as I go along, week by week. It may help to keep us from brooding."'[51]

Ironically, this act of charity eventually filled William Riley's own pocket, just as the philanthropic impulse to raise money for orphans had made an earlier fortune in lantern slides. Between hastily scribbled weekly instalments and finished bestseller, however, lies a story which makes it incredible that the book was even published at all. So successful was the story of *Windyridge* in keeping its initial audience from brooding, that the ladies urged William find a publisher. But with the depressing example of more egregious writers before him (like Charlotte Brönte, whose *Jane Eyre* was rejected by six publishers), William Riley was reluctant to face inevitable disappointment. He did agree to submit his manuscript but to one publisher only. His method of selecting the publisher was haphazard, yet fortuitous. On three slips of paper he wrote the names of three 'reputable' publishing houses and on a fourth the name of a new publisher, Herbert Jenkins. The name 'Jenkins' came out of the hat and William dispatched his brainchild, not knowing at the time that this 'new' publisher had not yet released a single volume and that *Windyridge* would be the first. At least that guaranteed the book the solicitude due to a first-born; in others' hands it would have been one book among many; for Herbert Jenkins it was *the* book.

In later life, reflecting on this sequence of events and trying to decide whether it was mere hotch-potch or pattern, William Riley convinced himself, with a faith at once arrogant and naïve, that his success was the reward of a God 'who will shape the lives of those who diligently seek him'.[52] There is more than a suggestion here of the Puritanism which sees

material success as the index of salvation.

Windyridge is still available on the open shelves of local libraries. Dust jackets on recent editions shout, 'a book that has been read by millions' or, 'a famous book that critics proclaimed a new *Cranford*'. (Ironically, the success of *Windyridge* enabled William Riley to move to Silverdale, where *Cranford*'s author, Mrs Gaskell, had lived.) By the time of William Riley's death in 1963, the book had been reprinted over thirty times, selling nearly 300,000 copies. In fact, this reputation and publishing history promises much more than the book actually delivers. But it is an enduring classic of popular fiction, thoroughly Victorian, even though not published until 1912.

The book tells the story of Grace Holden, a London-based photographer and artist, who takes on the tenancy of a cosy cottage in the hamlet of Windyridge on the edge of the Yorkshire Dales. (It is odd that William Riley, a self-confessed layman in the ministry of writers, should have chosen to tell his story from the point of a view of a woman. The publisher was sufficiently fooled, on receipt of the manuscript, to reply to 'Miss Riley', and one critic found it disconcerting that the author should dare to be a man.)

Like the life-model lantern slides, *Windyridge* blends romance, homily and adventure. All combine at the end of the book when the opinionated young dog of a man has a Great Change of Heart to take on the mantle of Hero. In a moment of truly gymnastic melodrama he rescues our heroine from the precarious remains of a cottage blown down in a gale; he calls her his darling 'in tones that sounded so anguished and oh! so distant'; and no more need be said.

The book also shares with the lantern slides a mawkish fascination with Death. The most famous character of the novel, Mother Hubbard, whose knitting needles and tea-and-hot-toast hospitality provide continuous accompaniment to the story, dies with a sense of moment and style that would do credit to any celluloid queen schooled in the ethics of Hollywood. Like the lantern slides, too, *Windyridge* pretends that the country is morally superior to the town: the heroine finds few seeds of discontent in the village to burgeon into weeds and spoil the view; the book is pastoral idyll.

For all its failings, *Windyridge* put the village of Hawksworth, outside Leeds, on the map, when it was recognized as the original for the book. Not all the villagers, of course, were entirely happy in the glare of publicity. Those who did teas for the trippers found a prosperous trade; but one old lady said she had read the book and: 'I think nowt on't. It's nowt but a pack o' lies from beginning to end.' Years later, in 1949, William Riley, then an

old man of eighty-three, revisited Hawksworth and took tea with the new owner of Mother Hubbard's cottage. She had kept the garden in a 'riot of colour' to tally with the description in the book. Outside the village the word 'Windyridge' acquired a fatuous currency. It rivalled Sea View as a hackneyed name for a cottage. Children and pets, too, suffered the indignity of being named after a bestseller.

The impact of all this on William Riley's life was nothing short of momentous, though he denied that the book made his fortune: it had to sell for six years before it compensated for the money lost in the collapse of the lantern business in the first six months of the war. Herbert Jenkins was quick to see the publicity value of the story behind the book. He urged William Riley to lecture in public on the origins of *Windyridge*. For several years this provided a lucrative sideline and a source of good anecdote.

The fame of *Windyridge* brought William Riley attention from what he called 'exalted quarters'. In January 1922, he was invited to a reception at Buckingham Palace, where, 'I was introduced to Their Majesties, King George V and Queen Mary, together with Her Royal Highness Princess Mary and the Earl of Harewood; and had the opportunity to inspect the wedding presents.'[53] William Riley records this moment's contact with Royalty with deference and pride as if it publicly set the seal on the self-making of a man whose father was a child labourer in the pre-Victorian Bradford. That explains why, of all the appreciative letters he received, William treasured one from the Duke of Devonshire, 'written by his own hand'.

With the end of the lantern-slide business, the Rileys' main ties with the city of Bradford were loosened and it was only a matter of time before they moved to a less smoky setting. The occasion came in 1919 when an outbreak of influenza all but killed William's wife. She appears throughout William's autobiography as a shadowy, mousy and weakly figure. Her frequent ill-health seems the main pretext for mentioning her. She was from the earliest days of their marriage 'unable to accompany her husband on even the easiest of his walks'. Her life was circumscribed by the house — 'cloistered', her husband acknowledged. With the arrival of motor cars, she became 'more adventurous' and managed the journey to Teesdale. There, while William sought out the wildest and remotest places, she sat in the hotel, looked out of the window and found satisfaction in her needle and her book.

The Rileys' choice of new home was Silverdale, an elusive village of scattered cottages outside Morecambe and which, in its remoteness and lack of mains water, must have taxed Mrs Riley. Small wonder that she stayed at home, chatting with 'Old Hayton' about the garden or sitting in

the summerhouse on the lawn knitting and embroidering for local Sales of Work. William's life at Silverdale was of greater moment. Although he was fifty-three years old when he left Bradford, he still had nearly half his life ahead of him. The lantern slides were things of his past. Before he died, William wrote thirty-six books — popular Yorkshire Dales novels, encomiums on the beauty of the North and a study of the prophet, Jeremiah.

The Rileys' parochial doings at Silverdale, as chronicled in William's autobiography — the building of the village hall and the bringing of mains water — are a reminder that, until very recently, it was possible for some people to let the world go hang. Most great events passed Silverdale by, but the village did not entirely escape the Second World War: 'Night after night, enemy planes or those of our own that sought to engage them roared overhead, and an occasional bomb was dropped in our neighbourhood.'[54] (As a boy, William Riley thrilled to the words of the recently-composed *Charge of the Light Brigade*, celebrating bravery in a rather different style of war.) The Rileys' home life was also disturbed by two evacuees from Salford, Mary and Dorothy, who 'gave us no more trouble than was unavoidable'; they were healthy and happy and 'respectable' working class. They also provided grist for the literary mill, figuring in the last-but-one of William's books.

His fame as a writer kept William in the public eye. Yorkshire claimed him as a 'son' with alacrity — especially as he hymned her beauty in books and eulogized her people. William Riley promoted the myth of the dour Yorkshire peasant — a shy, simple but profound thinker, wedded to the soil, shrewd and stubborn, awkward and shambling, speaking his mind and wanting all his gates kept shut. It was a sentimental brand of noble savagery that Riley peddled: 'Reality lies in the things that cannot be shaken — in the hills and the wild pasture lands where storms sweep by and leave no trace of their passage; in the grey home in the hollow; in the deep, but undemonstrative love of his own folk.'[55]

Those who welcomed this brand of folkery hailed William Riley as Yorkshire's 'premier novelist', though many recognized that his tales fed escapist longings: 'The people in the novel, the pathos and joy of the simple experiences, the little bits of homely philosophy — those are the things that make him so readable and enjoyable. They linger in the mind like the gracious memory of a midsummernight's dream of idyllic men and women we have never met and never hope to meet, but would be glad to.'[56] Like all restricted diets, however, too much sweetness cloys and degenerates to insipidity; in the end, William Riley's novels suffer from lack of sharp bite: they are too pretty and dainty.

In one respect the books are rooted in the real world — in their (thinly disguised) Yorkshire settings. From *Windyridge* on, there grew up an industry of 'spotting the places'. In 1932 the *Yorkshire Observer* ran a series of articles, 'William Riley's Yorkshire', tracing in detail the sites of the novels. Those places unlucky enough to be identified suffered invasions of literary pilgrims; the bonus was a boost in the market prices of local property. William Riley himself recorded with surprise that in 1950 'Windyridge' cottage sold for £2,415. (In May 1977, it was offered again, enlarged and modernized, as 'an olde worlde detached cottage residence' — for £42,000.) With so much at stake, disputes were inevitable. 'No. 7, Brick Row', the title of William Riley's third book, caused particular contention among those who claimed to have found the unlovely location. In an altercation in the Bradford *Telegraph and Argus* in March 1936, W. F. G. Phillips claimed to have taken photographs of the authentic house, when a film was being made. He found it at 11 Wood Street — and baffled the neighbourhood by sticking a number 7 on the door.

Fêted as a local worthy, William Riley metaphorically stood in line with those who had ignored him at school; he wrote one article in a series for the *Yorkshire Observer* by 'Old Boys of Bradford Grammar School who have attained distinction in different spheres'. In 1930, he presented the prizes at Speech Day at Salt Boys High School; when William Riley was a boy, Saltaire was a new model wonder still in process of construction. In his address he spoke of the rôle of the young: it was their job, he said, 'to put foundations under the old men's castles in the air'.

If he thought he himself was old at that time, William Riley still lived another thirty-one years before he bequeathed his own castles to the young. When he died, in June 1961, the lantern-slide business was over half a century away. Magic lantern entertainments had been supplanted by the cinema, which itself fought for its life against television. No one remembered the Rileys' lantern slides; the remnants had long been consigned to dust and damp. At his death William Riley was commemorated only as writer and man. In the funeral tribute, the Reverend George Graves saw the man through the books: he spoke of William Riley's 'essential humanity' that 'stemmed from the fact that he was a Yorkshireman and that in turn made him impatient of any pretension whatever'.[57]

William Riley made no claims to a fortune; he always protested he had made little from his books (except friends). Those who raised incredulous eyebrows were proved wrong in the end — he left just over £7,000. All that had come from the books; a cellarful of glass was all the remains of a lantern-slide business that had once spanned the world.

Notes and References

1 *Memoirs of Benvenuto Cellini*, trans. Anne Macdonnell, Dent, 1907, pp. 98–101.
2 Harriet Martineau, *Autobiography*, 1877.
3 W. H. Golding, *Vagaries and Variations in Popular Taste*, in *The Optical Magic Lantern Journal*, November 1901.
4 ibid., October 1890.
5 ibid., January 1891.
6 C. Goodwin Norton, *The Lantern and How To Use It*, Hazel, Watson & Viney, 1895.
7 Henry Mayhew, *London Labour and The London Poor*, Dover Facsimile Edition, 1968, vol. 3, p. 72.
8 *The British Journal of Photography*, 28 December 1888.
9 Colonel Mellor, FRAS, in *Chamber's Journal*, no. 288, 9 July 1859.
10 *Chambers Edinburgh Journal*, 1858.
11 A clear account of spherical and chromatic aberration appears in *The Lantern and How To Use It*: 'In passing light through lenses the optician meets with difficulties, the most troublesome being that white light is composed of rays of different colours, the chief being red, yellow and blue. These different rays cannot be made to refract at the same angle by any single lens yet known to science; consequently, one action of a lens is to split up the light into these colours, the same as a prism does, a lens being neither more nor less than a series of prisms.

'This for many years retarded the progress of optical science. The problem was too difficult for the great Sir Isaac Newton, who abandoned lenses and used reflectors for the only optical instrument then in practical use, the telescope, but in 1745 it was shown by Dolland that the coloured rays could be reunited by passing light through lenses of different dispersive and refractive powers. This is called correcting chromatic aberration, and in practice is done by joining two lenses together, the right-hand lens being known as flint glass, the left-hand crown. These two are often cemented together to avoid loss of light from so many reflective surfaces, and to the ordinary observer appear as one. This kind of lens is used for lantern objectives, and is known as the single achromatic plano-convex.

'The next difficulties are curvilinear distortion and spherical aberration. It was stated earlier that the solar focus of a lens was that distance at which it would bring all parallel rays to a point; but this is not strictly true of lenses which have their curves part of a circle. Mathematicians say this can only be done when the curve of a lens is hyperbolic, parabolic or elliptical; the lens-grinder's view of the subject is that lenses of these shapes cannot be ground, or, if they could, they would answer the purpose, or, if they answered the purpose, it would not pay to grind them. These defects, inherent in all single lenses, make straight lines on

the lantern slide, especially those very near the edges, to appear as curved on the screen, and the image or picture to appear fuzzy, either in places or all over; but these may be partly or wholly corrected by the use of two or more lenses.'

12 J. M. Turnball, *Photometric Values of different lights used for lantern purposes*, in *The British Journal of Photography*, 1874.
13 Walter Bentley Woodbury (1834–1885) was an English professional photographer; he invented the 'Woodburytype' — a photomechanical printing process, famous for its high definition and lack of grain. He also worked on balloon photography and on stereo-projection. For his 'Stannotype' process he received the progress medal of the Royal Photographic Society in 1883.
14 *The British Journal of Photography*, 1 March 1878.
15 ibid., 31 January 1890.
16 *The Photogram*, January 1899.
17 *The British Journal of Photography*, 23 April 1869.
18 From C. Goodwin Norton, op. cit.
19 *The British Journal of Photography*, 18 April 1873.
20 *The Optical Magic Lantern Journal*, June 1889.
21 C. Goodwin Norton, op. cit.
22 Quoted in, Olive Cook, *Movement in Two Dimensions*.
23 William Riley, *Sunset Reflections*, Herbert Jenkins, 1957, p. 41–2.
24 *The British Journal of Photography*, 7 July 1865.
25 ibid., 4 November 1886.
26 T. C. Hepworth, *The Book of the Lantern*, 1890.
27 *The Optical Magic Lantern Journal Almanac*, 1896–7.
28 ibid.
29 For his father's story, William Riley is indebted to the survival of his father Joseph's Journal, which he wrote when he was over seventy and which, fortunately, came into William's hands only shortly before his father's death.
30 William Riley, op. cit., p. 19.
31 ibid., p. 14.
32 ibid., p. 15.
33 ibid., p. 37.
34 ibid., p. 182.
35 *Phases of Lantern Development*, in *The Optical Magic Lantern Journal Almanac*, 1896–7.
36 William Riley, op. cit., p. 50.
37 ibid., p. 81.
38 H. J. Walker, *Animated Photographs v. Dissolving Views*, in *The Optical Magic Lantern Journal Almanac*, 1897–8.
39 'Perhaps the most effective of all mechanical slides is the one representing the ship sinking in mid-ocean. This always excites wonder as to how it is done and yet it is really very simple. The sea, boats and a little of the sky are painted on one slide. The second slide consists of two glasses, on one of which is painted the ship, which can be moved up or down as required, and on the other glass is the sky and a little of the sea. Each slide forms a little more than half a circle. They must be brought on together, or half the screen will be blank; this necessitates the use of three lanterns. When the glass having the ship painted on it is lowered, or rather raised, the ship disappears behind the smaller or blank half of the slide. The two slides must be properly tinted near where they join, or the illusion will be spoiled. The motion of the ship sinking may be controlled by simple lever or by rack and pinion.' From *The Lantern and How To Use It*.

40 ibid.

41 *The Optical Magic Lantern Journal Almanac*, 1898–9.

42 Cassell's magazine, 1880.

43 Chambers, *Journal of Popular Literature, Science and Art*, April 1894.

44 *The Times*, 18 October 1894.

45 *The Globe*, 31 August 1896.

46 Anna de Bremont, in *St Paul's Magazine*, 7 March 1896.

47 *The Amateur Photographer*, 11 December 1896.

48 Stills from Le Prince's film are permanently on display in the reception area of the BBC television centre in Woodhouse Lane, Leeds.

49 Patent, Class 97, no. 24, 506, 16 December 1894.

50 Riley Brothers' Catalogue.

51 William Riley, op. cit., p. 98.

52 ibid., p. 181.

53 ibid., p. 150.

54 ibid., p. 169.

55 ibid., p. 148.

56 Review of *Windyridge* in *The Bookman*, October 1912.

57 *The Bradford Telegraph and Argus*, 9 June 1961.

Riley Brothers 'Home Bath Cabinets'

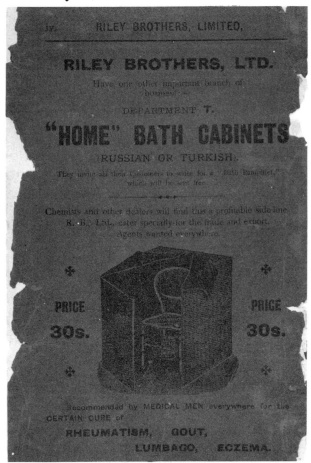

Street Life

One set of slides, produced by the Rileys in about 1890, caught the eye of the editor of the *Optical Lantern Handbook*; he referred to 'a sequence that has especially taken our fancy . . . the slides are taken directly in the street and show the natural surroundings . . . extremely good and realistic'. The key words are 'directly', 'natural' and 'realistic'; they suggest that photographs of ordinary people in city streets were themselves uncommon enough to deserve notice.

Not that all affluent Victorians thought life on the streets beneath their attention. They were constantly reminded of the paradox of wealth and poverty increasing together, the 'arithmetic of woe', to use Charles Booth's phrase.[1] As early as the 1840s Thomas Carlyle had voiced his concern: 'In the midst of plethoric plenty, the people perish; with gold walls and full barns, no man feels himself safe and satisfied.'[2] Two years later Disraeli saw the haves and the have-nots as, 'Two nations between whom there is no intercourse and no sympathy; who are as ignorant of each others' habits, thoughts and feelings, as if they were dwellers in different zones, or inhabitants of different planets.'[3]

In the next half century a new breed of writers made journeys to the alien poor: James Greenwood, George Sims, Charles Booth, William Booth, Seebohm Rowntree and Jack London. Their reports are a mixture of grim anecdote, statistic and protest. Their favourite words, 'outcast', 'darkest', 'submerged' and 'abyss', suggest that they found a world both horrific and sinister.

These writers' bleak pictures of the life of the poor are all drawn in words; the camera, which in the twentieth century shouts louder, did not accompany them to the 'dark side of life'. The reason was partly a technological one: the majestically slow and cumbersome techniques of photography made it unsuitable for recording the 'naturalistic' life of city streets, until the third quarter of the century; and photographs could not be reproduced cheaply in newspaper and magazines until the last years of the century.

A second reason for the shortage of pictures of street life was that photographers in general were not socially 'aware'; very few saw their job as bringing into polite drawing-rooms disconcerting reminders of the horrors of poverty. Rather, they allied themselves and their 'art' to a genteel middle class, pandering to its tastes. Henry Mayhew's 'Photographic Man' (who also removed warts and dyed hair) was happy to swindle his clients by relying on their vanity. He took sixpenny or one-shilling portraits; 'for colouring we charge 3d more. If the portraits are bad or dark, we tell them that, if they have them coloured, the likeness will be perfect. We flesh the face, scratch the eye and blue the

coat and colour the tablecloth. Sometimes the girl who does it puts in such a lot of flesh paint, that you can scarcely distinguish a feature of the person. If they grumble, we tell them it will be all right when the picture's dry.'[4] Apart from the studio portrait, landscape and architecture were the main concerns of photographers.

They also avoided the streets quite simply because they were afraid. The commonly-presented sensational picture of the poor as a subhuman horde seething rebelliously in darkness deterred most photographers from straying too far from their safe and pretty path. 'J. M. W.' recalled with horrified and fearful fascination a Sunday-afternoon expedition with camera to the 'haunts of the great unwashed' in London's Commercial Road, to take real-life pictures for a church society lecture:

We moved forward and, descrying another specimen further on, we watched him for a short time, when, to our mingled surprise and disgust, we actually saw him pause, walk into the middle of the roadway, stoop down and pick up a rotten pear . . . and begin to eat ravenously . . . I was so taken aback by this action of his that I forgot what an excellent picture he would have made.[5]

One rare exception was the team of John Thomson and Adolphe Smith. John Thomson, born in Scotland in 1837, had already made a name for himself as photographer with startling pictures of the Far East, when in 1877 Adolphe Smith, a London journalist, suggested collaborating on a book about the slums of London. They hoped that the 'unquestionable accuracy' of the photographs in their *Street Life in London* would save

them from accusations of exaggeration in describing the plight of, for example, the 'Crawlers' of St Giles: 'Old women reduced by vice and poverty to that degree of wretchedness which destroys even the energy to beg.'

Two other people in particular influenced the Rileys in making their pictures of street life. First, Henry Mayhew, whose mammoth personal survey of the life of the streets of London appeared in four volumes in 1861. The text was illustrated with engravings of individuals plying their trades. The Rileys issued a set of lantern slides drawn from Mayhew's pictures and called *The Street Criers of London*, illustrating 'the shifts adopted by those in large cities to eke out a miserable existence'.[6] Several of the subjects — the Oyster Stall, Baked Potato Man, Punch's Showman and others — appear again in Rileys' own pictures.

The second debt the Rileys owed was to Charles Haddon Spurgeon, the magnetic baptist preacher, whose oratorical gifts were recognized early (he preached his first sermon at the age of sixteen). At the end of Spurgeon's life the Rileys contributed to his almost legendary reputation by issuing two sets of slides, one on *The Life and Works of Pastor Spurgeon* and another, *John Ploughman's Pictures*, based on a fictional character in Spurgeon's writings. The great preacher liked the Rileys' slides: 'a triumph of ingenuity . . . I have never seen better pictures and hardly think that better could be produced.'[7] Charles Spurgeon had himself commissioned a remarkable series of street-life slides in 1884.

In making their own pictures the Rileys did not share the moral fervour of Mayhew, Thomson or Spurgeon.

Though they were claimed to be 'interesting and educational', the slides were also designed to 'evoke roars of laughter'. The lantern lecture which accompanies the slides is, accordingly, an odd compendium of moral precept, worn jokes and heavily-carried erudition. It opens seriously enough with Alexander Pope's maxim that 'the proper study of mankind is man'; the pictures should help the audience realize 'something both of the hardships and the compensations of these busy toilers in the city highways'. Those in the audience of delicate sensibility, however, were quickly reassured: there will be nothing uncouth to shock them — no 'heart-rending scenes of poverty and degradation which are only too commonly to be met with in city life'. The lecturer promised instead to focus on more comfortable scenes, those which 'collectively give life and animation and colour to the gloomy streets'. Poverty in this lecture, then, is fair game for condescending humour: the man who carries the flag in front of the steam road-roller was not paid enough, we are told, to keep body and soul together; 'he was so thin that when he had a pain he couldn't tell whether it was stomach ache or back ache'. So, too, the tinker at his stall, pathetically trying to stay afloat on others' jetsam, is the butt of a joke about having to sell even his own bed. And although the knife-grinder's job can have had little to do with poetry, we are assured he is a 'merry soul' — 'there seems to be something in the whir of the wheel and the whiz of the steel and the sparks that fly so bright that inspires mirth and conduces to optimism, for this particular knight of the table is a man who believes life to be worth living'. It must have been a welcome salve to the conscience of the audience to hear that those who had much less than themselves were, at least, happy with their lot. Riley Brothers' street-life slides, then, were no cry of protests on behalf of the poor; they were designed to throw cheerful colour, not sombre shadows, on to the screen. In another of their slide sequences, *Slum Life in Our Large Cities*, the Rileys appear to have peered into darker more dismal corners, but the audience is assured that the rags and squalor are caused 'very largely by drink'; in other words, that the wretchedness of the poor is self-induced. The audience is left free to feel appalled but not culpable. Very few lantern slides pointed accusing fingers at them.

Quotations in the captions accompanying the slides are from Riley Brothers lantern lecture unless otherwise indicated.

Notes and References

1 Charles Booth, *Life and Labour of the People in London*, 1889–91.
2 *Past and Present*, 1843.
3 *Sybil*, 1845.
4 *London Labour and the London Poor*, 1861.
5 *Hand Camera Experiences in East London*, in *The Optical Magic Lantern Journal*, January 1899.
6 Riley Brothers' Catalogue.
7 ibid.

The Steam Road Roller

'You will notice the youth in front carrying an apology for a flag. He is a relic of mediaeval times. Often have we seen him pacing slowly along the street with his red flag over his shoulder, some quarter-of-a-mile ahead of the fiery monster which is going to or returning from the scene of action. He is supposed to warn people from the path of this noiseless Flying Dutchman, and the number of lives which have been saved by his instrumentality will probably never be known. The man tells us he is paid next to nothing for what he does and it won't keep body and soul together. He was so thin, he said, that when he had a pain, he couldn't tell whether it was stomach-ache or back-ache.' (In fact, red flags were obligatory before horseless carriages until 1896.)

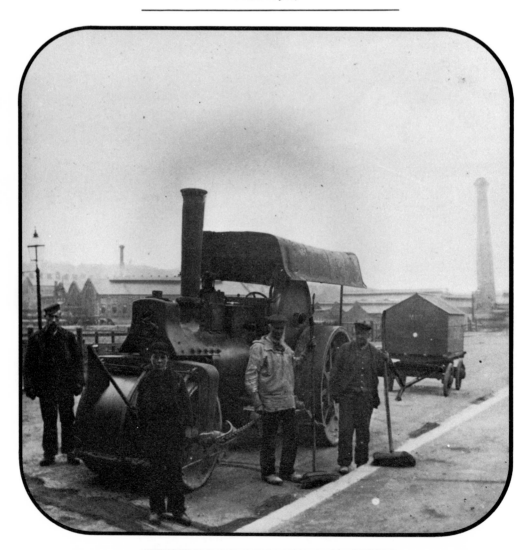

The Shoeblack

'The business-like way in which he seizes our foot, places it in position, and with both hands at once polishes away until his face is reflected on the glossy leather, commands our respect, and compares favourably with the slow but gracious manner in which the Parisian shoeblack rises from his stool and, after politely bowing to his client, places his foot with mathematical precision on the stand and, with the cautious deliberation of the artist, proceeds to remove the dirt from his pedal coverings.'

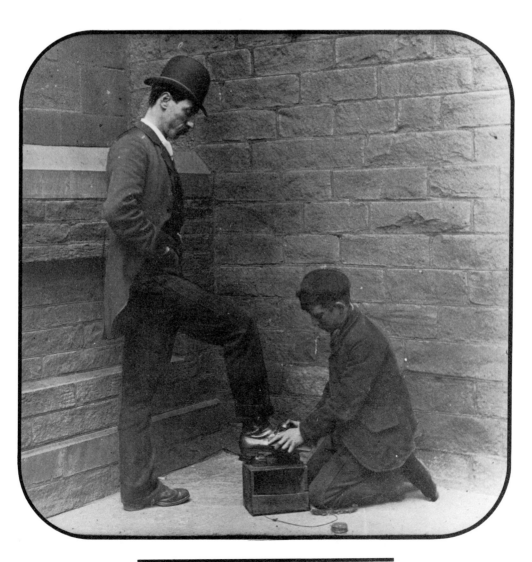

The Italian and his Monkey

'Very often the monkeys are the almost inseparable companions of their trainers and display uncommon attachment to their masters. It is related of one such that, when his master in a fit of depression shot himself dead with a revolver, it grasped the pistol tightly in both hands and emptied the contents of another barrel into its own throat.' Henry Mayhew interviewed an Italian with a monkey dressed 'comme un soldat rouge, like one soldier, vid a red jacket and a Buonaparte's hat'. This monkey could only remove its hat, but his predecessor could play the drum and fiddle, sword-fight and waltz. But he died after eating red paint.

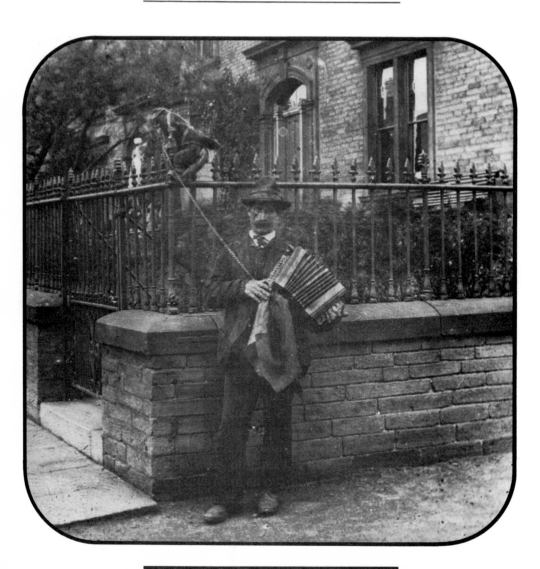

The Gas Inspector

'Is regarded as a man who, in some unaccountable manner is leagued in conspiracy with the untruthful machine by which our supply of gas is regulated. In fact, an opinion has prevailed that the gas meter is a contrivance which works twenty-seven hours a day, eight days a week the year round'.

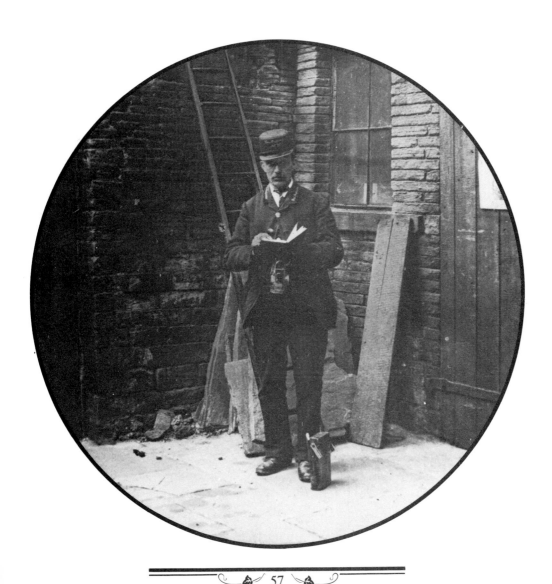

The Crossing-sweeper

'It is to be feared, he is dying out . . . We have heard the story of their hardships . . . How that in the early morning they must rise from their beds — though more frequently the bare boards of a bare garret or the cold stones of a friendly arch must serve for their couch, and their rags must be their coverlets — and with their broom over their shoulder trudge away to their own particular crossing and diligently set to work for the comfort and convenience of the crowds, out of which only two or three will now and again pause to drop a penny into the little fellow's hand.' According to Mayhew, crossing sweepers were one of the largest and the lowest of the classes of street folk: 'One of those occupations which are resorted to as an excuse for begging . . . the last chance left of earning an honest crust.'

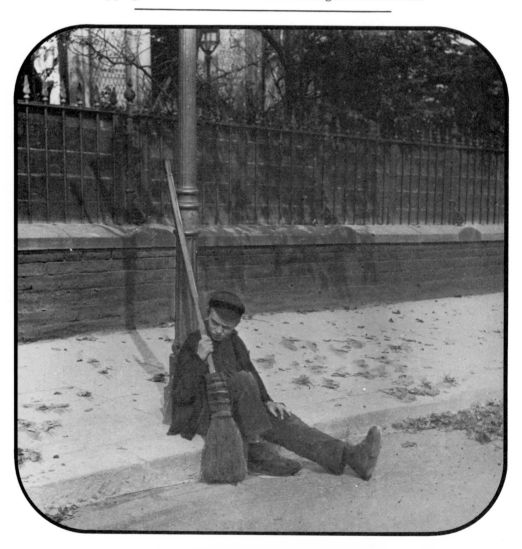

The Painters
'Being well-paid for his work, and kept fairly busy the year through, he has little to complain about.'

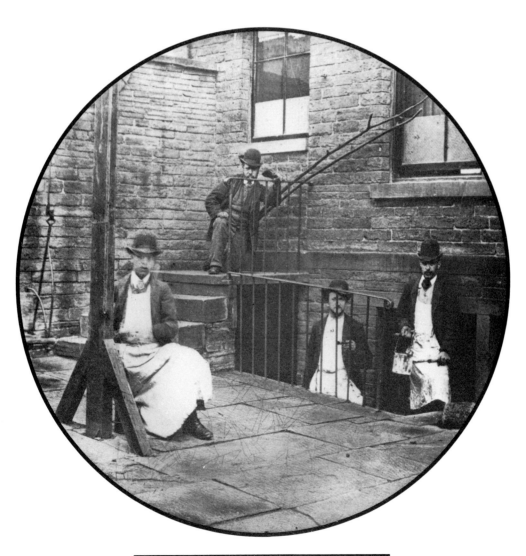

The Street Piano

'The disabled sailors, who are the owners of the panoramic piano in our picture, had been so unfortunate as to meet with such injuries on board ship. A board on the top gave particulars to the "kind friends" who might be disposed to help, whilst by the revolution of a handle, a wooden ship was made to toss up and down on the cardboard waves of a counterfeit sea.'

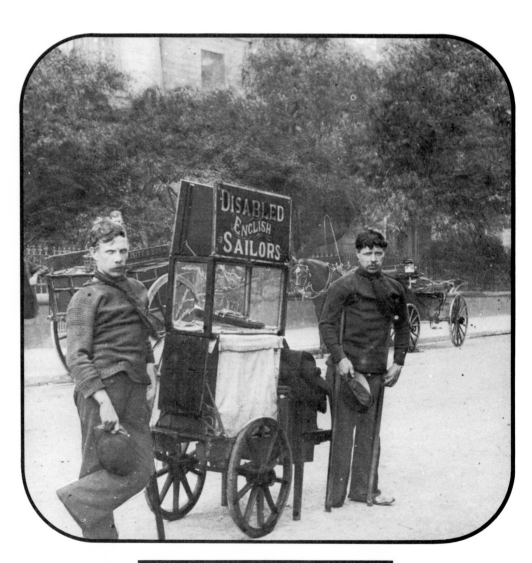

The Billposter

'The average town billposter is very proud of his skill. He knows how much is dependent upon his good taste and his good judgement; he knows just which colours will go well together and which styles of printing will best set each other off.'

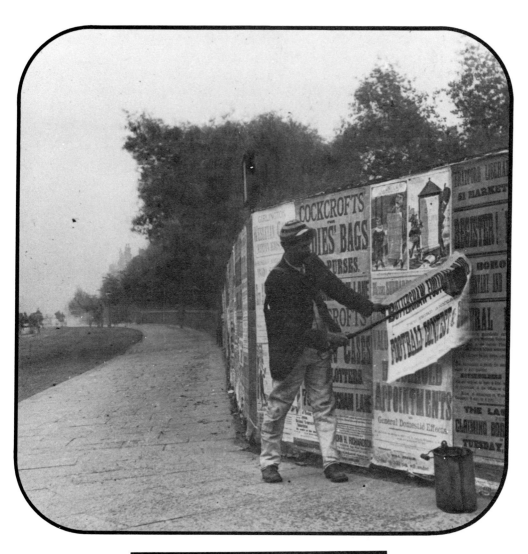

Errand Boys
'We, at any rate, cannot afford to waste time as readily as they can.'

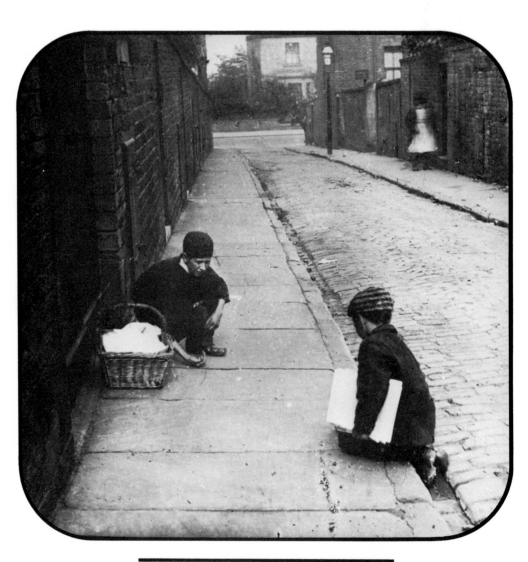

Punch and Judy

'A recognized British institution.' The first Punch showmen, Porsini and Pike, brought their show from Italy in the 1780s, according to Mayhew. They died in the workhouse as do all 'Punchy' men, claimed Mayhew's informant. He said he had bought up Porsini's own show for 35s and performed at private parties and in the streets, where young boys gave them trouble: they threw caps into the frame, poked their fingers through the baize, tapped the drum and always shoved into the best places 'without a farthing to bless themselves with'. 'Ah, it's a great annoyance being a public Karracter, I can assure you, sir; go where you will, it's "Punchy! Punchy!".'

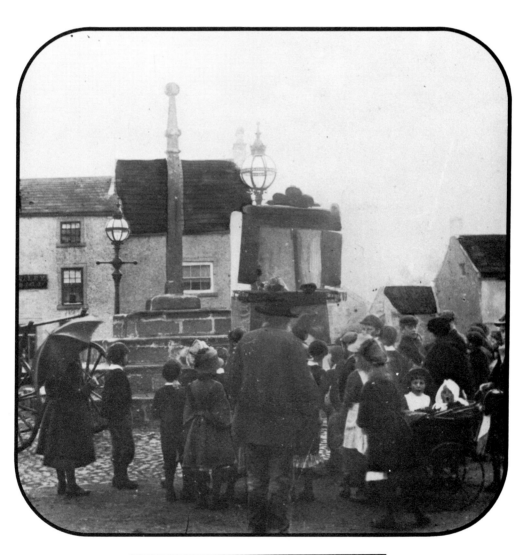

The Milk Boy

'The milkman is a being who is constantly made to feel that he is an object of suspicion. He is supposed to be well acquainted with such scientific matters as the solubility of chalk in water and he hears his clients say that it's a well-known fact that you can't mix oil and water, and they wish they could say the same thing about milk and water.'

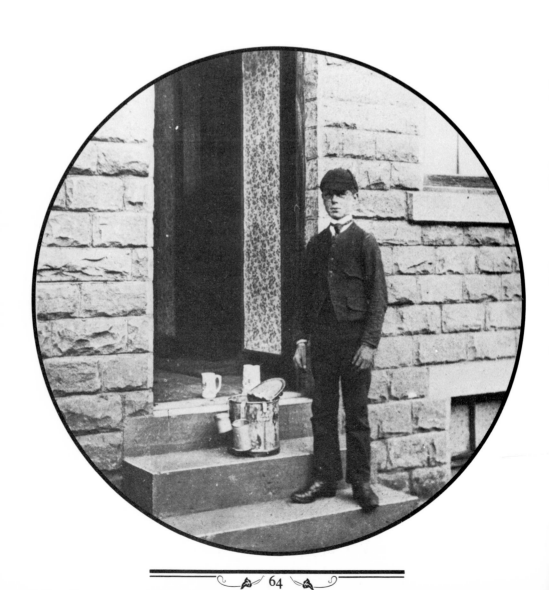

The Advertising Shoe

'The larger firms strike out on a larger scale and send out colossal representations of their own special business. Such is the boot before us; whilst a well-known soap firm send round a gigantic, wooden cannon to draw attention to their commodity.'

The Hansom Cabby

According to Henry Mayhew, hackney-cabriolets (to use the full name, already pedantic in Mayhew's time) were introduced to the streets of London, after the Parisian example about 1820. Various shapes and sizes were tried, but by the 1850s only Clarences (carrying four passengers inside) and Hansoms were in use. Hansoms were called 'showfulls' by the cabmen — a slang name, meaning counterfeit; that is, an infringement on Hansom's patent. Mayhew met many quondam traders (and even a baronet) turned cabmen. He was informed that at least ten per cent of them were 'fancy men' (pimps); that would mean over five hundred. 'To get a cab,' Mayhew was told, 'is the ambition of more loose fellows than for anything else, as it is reckoned both an idle life and an exciting one.'

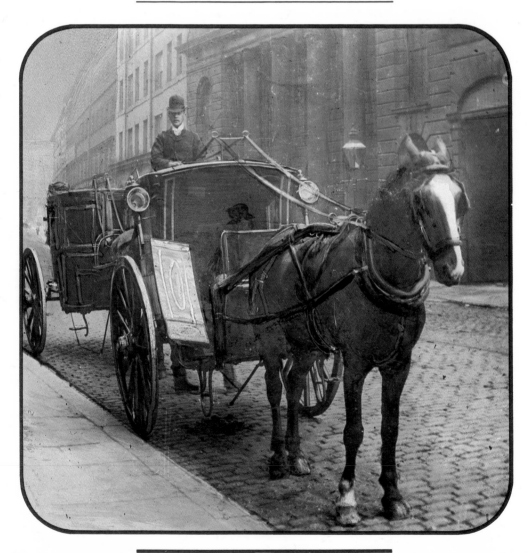

Two Old Fruit Women

'These fruit women always seem to enjoy a higher position in the social scale than their brother vendors of baked potatoes, pigs' feet, etc., for on these latter some people are disposed to look with scorn.'

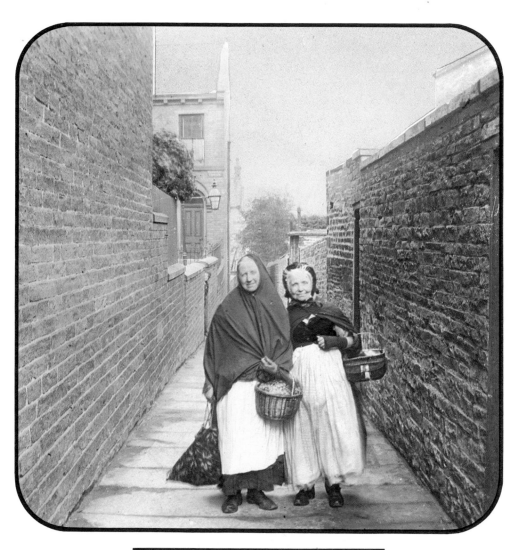

Tinker at His Stall

'Odd bits of whalebone, brass pipes, lead tubes and a variety of nameless articles of all kinds. It reminds one of the reply which was once made to a gentleman who, coming across a pile of these things by the side of the road, asked a young street Arab: "Where in the world did these come from?" "Dunno," he said, "'spects some unfortunit female was wrecked hereabouts."' Henry Mayhew was more sympathetic towards second-hand street traders: 'In London, where many in order to live, struggle to extract a meal from the possession of an article which seems utterly worthless, nothing must be wasted.'

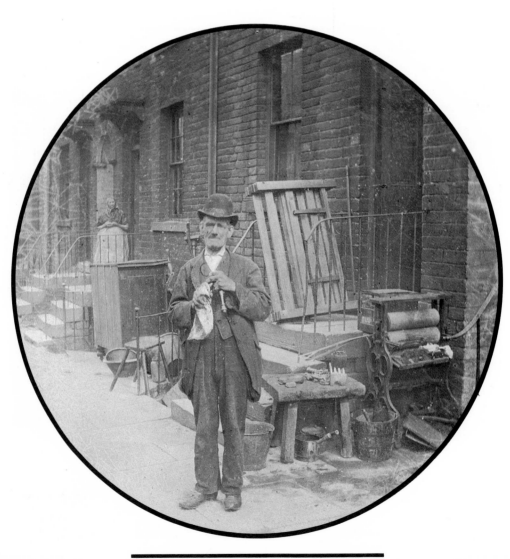

The Nurse Girl

'She has not the distinctive garb like that of her Continental sister, yet it is a fact that the gallant soldiers of Her Majesty never fail in discriminating her . . . drawn by a natural gravitation to their coveted quarry . . . It is said that the Life Guards have been compelled to charge 5s per night for escorting these fair maidens, so great is the demand for their services. Only cooks can afford to indulge in so expensive a luxury.'

The Knife-grinder

'His occupation has little to do with poetry . . . In former days the travelling cutlers did a good trade, but it has fallen off considerably and the few there are left generally make their way to country places.'

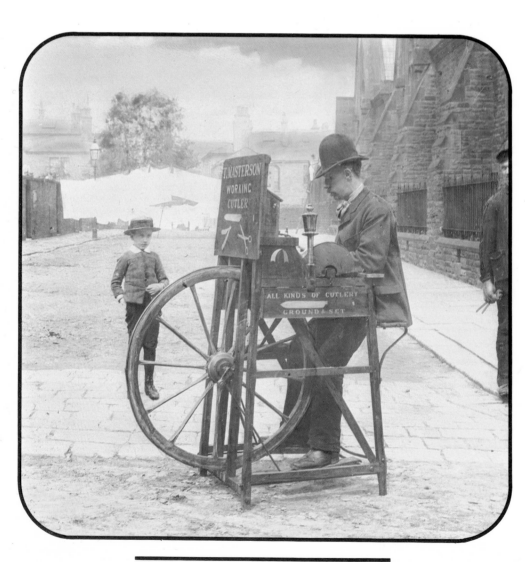

The Brewer's Man

'He is frequently accused of being stout, and is unable to explain why that should be a common characteristic of his class. Some people have theories of their own, however.'

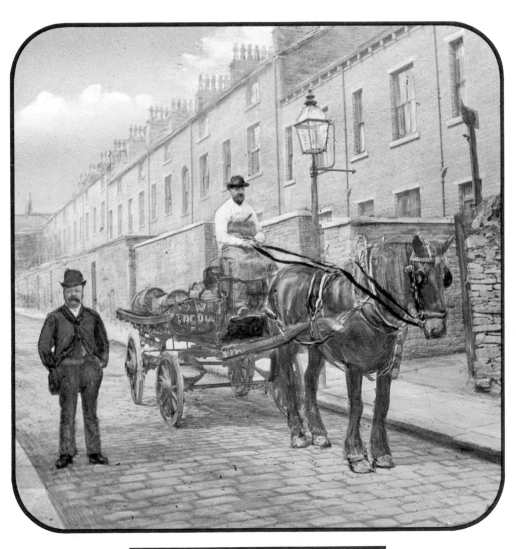

The Rhubarb-hawker

'The coster is only known in the larger towns of the land and his home, par excellence, is the East End of London. Here are probably some 60,000 of them. Their name is derived from the word 'costard', a particular kind of apple which they used to sell. Their working life is passed in the streets and, though many of them are sober and pious people, the great majority spend their leisure in the bar-parlour and the music hall.'

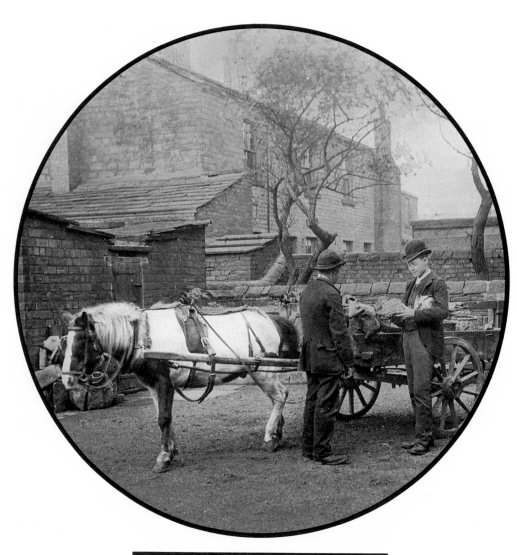

The Flower-seller

'They much prefer the rougher sex for customers because they are less fastidious.' Mayhew had a less charitable explanation: some flower girls, he said, 'avail themselves of the sale of flowers in the streets for immoral purposes . . . mixing up a leer with their whine for custom or for charity.' Mayhew met a flower girl, not yet nineteen, who had been imprisoned for three months for 'heaving her shoe at the Lord Mayor'; she preferred a cell to wandering the streets. Perhaps because of bad sanitation in cities, flower girls found sweet flowers the only ones in demand — primroses, violets, wall flowers, stocks, roses, carnations, lilies of the valley, green lavender and mignonette. With great precision, Mayhew estimated that in the late 1840s, 994,560 cut flowers were sold yearly in the streets of London.

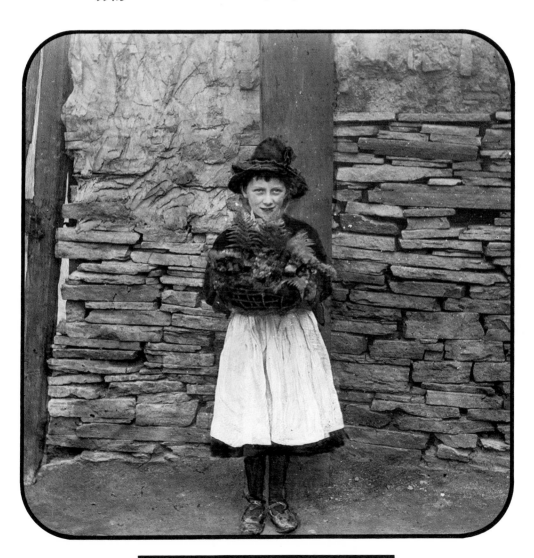

The German Band

'Now the German Band is a power in the land . . . the number must be on the increase.' Forty years before, in Mayhew's time, there were five German bands in London and one or two elsewhere in the country. Mayhew's informant himself came over with six others (at the age of fourteen) from Oberfeld to Hull. He played the clarionet (as did two others); one played the trombone and one 'ze saxhorn'. They played a repertoire of opera tunes at private parties and public dances, undercutting English bands (who therefore abused them). London had its attractions: 'ze London beer is very goot and sometime we drink a goot deal of it!'

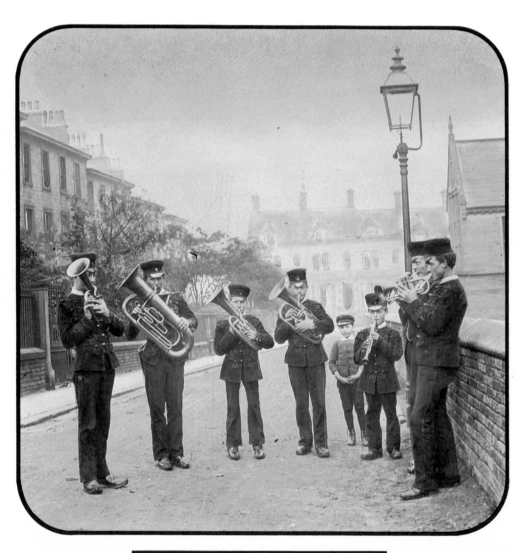

The Oyster Man

'"You might think," says he, "that it is only a common sort o' people stops here for a penn'orth or two, but you're wrong there. There's many a swell chap as looks up and down the street and then says, 'Just open a few oysters, mister, quick;' and then walks away as grand as if he'd never seen the stall." . . . In London the oyster stall is not so common a sight as it once was and the trade seems to have become too respectable to be carried on in the streets.' Oyster-selling was one of the oldest street trades in London; it dated from at least Roman times. Trade really exploded around 1848 with the arrival of 'scuttle-mouth' oysters from the Sussex coast. Then they sold at two for a penny.

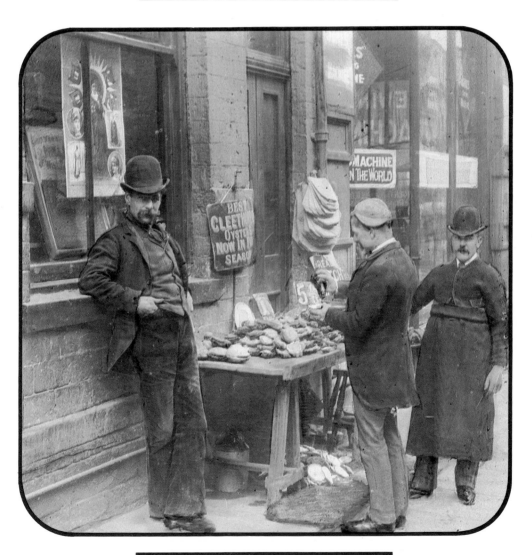

The Fishwives

'One would think there was little connection between fish and courtship, between mackerel and matrimony but . . . after a successful fishing season in some parts of the kingdom the marriages are eight per cent above the average.'

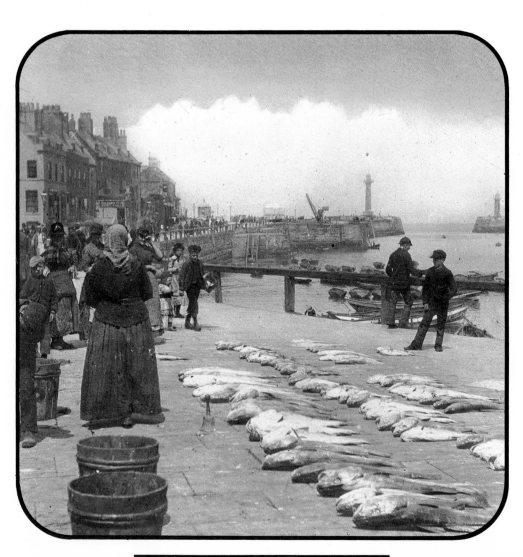

Two Fish Boys

'They are getting rather sharper now but there was a time, not very long ago, when their ignorance of booklearning was both amusing and distressing.'

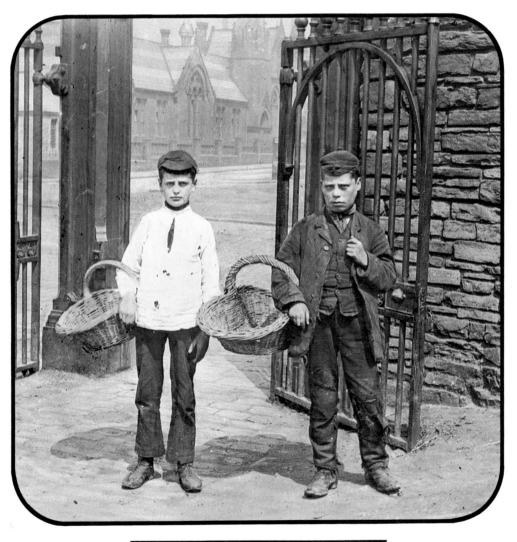

The Ice-cream Stall

'Of late years a solidified form of ice-cream, known by various names but commonly called hokey-pokey, has become very popular and, as it is neatly wrapped in white papers and the methods of manufacture and dispensing are not so apparent as in the old form, the new commodity has found favour with a class of people who before fought shy of the ice-cream man.' Mayhew says that ice-cream was only introduced 'last summer' (1848?) — by a man who soon abandoned it and emigrated to America. Sales had not been sufficient 'such as to offer any great encouragement to a perseverance in the traffic'. Some treated the new-fangled luxury with disdain and wondered what next: 'Penny glasses of champagne, I shouldn't wonder.' Mayhew reflects that other rumunerative commodities had a slow start — such as rhubarb.

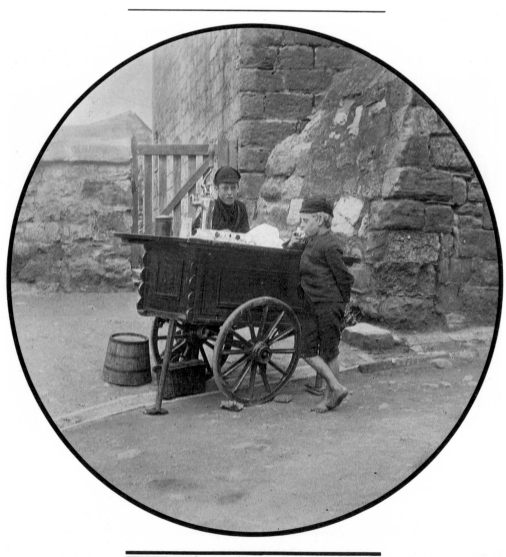

The Sandwich Man

'What are we to call him? He is a kind of double sandwich, inside a square box, the sides of which are covered with advertisements . . . One theatrical company sent round a number of men, each of whom carried a baby doll strikingly dressed, and the sheepish way in which some of these amateur nurses held their charges, provoked much merriment and not a little chaff.'

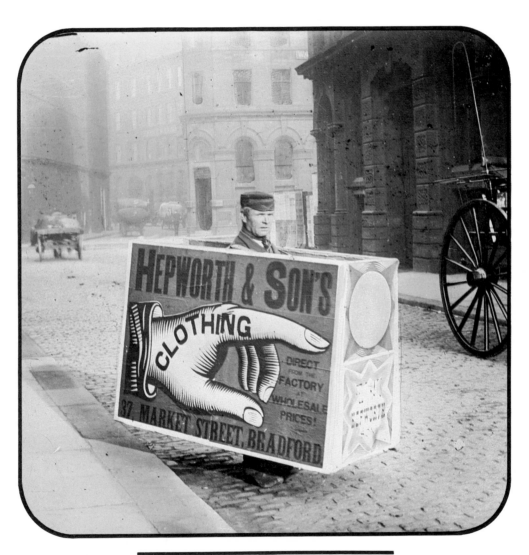

The Baked Potato Man

'The baked potato man's trade is a very respectable one and the man is looked upon by numbers of the poor as a boon and a blessing to men.' Not only was his fare cheap ('a copper purchases a very liberal supply') but he provided an excuse 'for lingering awhile around a ruddy blaze'. The baked potato season ran for six months from August to April. Large 'French Regent's' were the most popular potato (only two or three to the pound). Mayhew estimated that sixty tons per week were eaten in the streets of London, though some people only bought them to keep their hands warm.

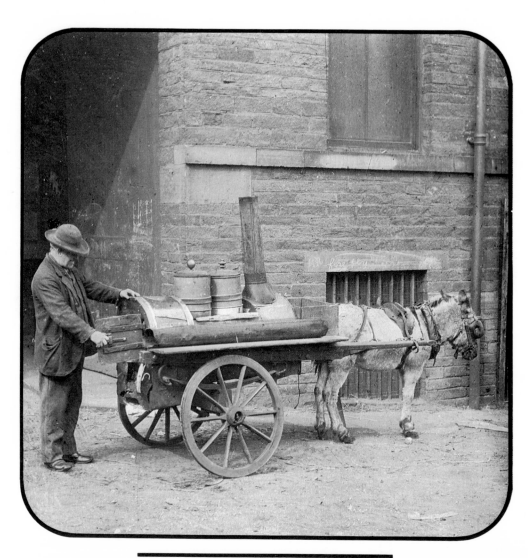

The Box-Organ Grinder

'Fortunately for us, though it can depict the instrument of torture, the camera cannot perpetuate its agonising sounds. By the 1890s the box-organ was losing to the superior street piano in the struggle for survival. However, some organ grinders claimed still to be able to earn four or five shillings a day.'

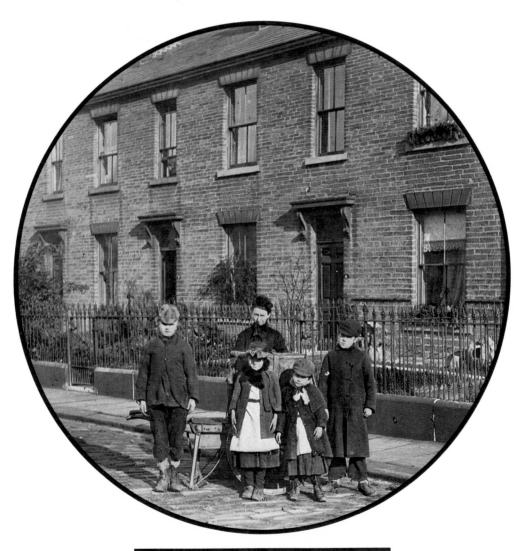

Life~Model

One huge section of Riley Brothers' catalogue is headed, 'Life-Model Series'. The title means nothing to the layman today, but it covers the most popular of all lantern slides in pre-cinema days: illustrated narratives — popular fiction, tract and song — recited to the accompaniment of slides in which amateur 'actors' modelled the scenes.

A near neighbour of the Rileys was the pioneer of life-model slides: Joseph Bamforth of Holmfirth (who later collaborated with the Rileys to make movies). In the 1890s Bamforth claimed to be 'The Largest Producer of Life Model Slides in the World' (although this was a business where such hyperbole was common). Bamforth had set up a studio with costume, props and scenery departments, which rivalled those of later film makers:

> The premises in which the business is conducted are curious in the extreme, consisting, as they do, of a series of successive studios and workshops perched at various points on a precipitous slope between the house, which overlooks the valley and the village of Holmfirth, and the first studio, which is well down towards the valley. This slope, almost impossible for cultivation as a field, has been banked, terraced and dotted with flights of steps, fountains, shady walks, leafy dells and pleasant summer-houses in a

variety which might be thought impossible in such a space . . . The life-model studio is a room of 31 feet by 18 feet with a scene dock and a property room at each end; and with roof light and side light at both sides.[1]

The flesh and blood in the studio was provided by the local inhabitants of Holmfirth: 'Policemen can always be borrowed, in their own uniforms "by arrangement", but real soldiers and firemen are not so easily obtainable in Holmfirth . . . Fortunately, the railway officials are always willing (subject to the calls of duty) to place a train in any position.'[2]

The Rileys had their own, less elaborate, studio in their premises in Bradford, though it, too, could run to startling effects. William Riley contributed a story or two and painted the scenery. Occasionally the Rileys took a camera 'on location', for example to the quaint but then insanitary fishing village of Runswick, on the Yorkshire coast, where the locals were pressed into service as ad hoc performers.

Some of the Rileys' life-model slides were made to introduce the unschooled to (abbreviated) literature: *Alice in Wonderland*, *Enoch Arden*, and extracts from Dickens and Shakespeare — all appear in the catalogue. Classical stories, too, were included but often ludicrously trivialized: in *Diogenes and the Naughty Boys of Corinth* the philosopher is squirted with water through a

bung hole in his barrel.

What really touched the hearts of ordinary people in life-model slides were sentiment and melodrama. Universally popular were the *Dagonet Ballads* of George R. Sims, which dramatized the sufferings of the poor. Published in the 1870s, Sims' ballads were a goldmine to the makers of lantern slides; *Billy's Rose* and *In the Workhouse: Christmas Day* became minor classics of their kind. Sims was no mere sentimentalist: he had first-hand experience of his grim subjects. He inherited a radical streak from his mother, and for his articles, *How the Poor Live*, he explored the South and East End of London to find 'the soul of goodness in things evil', which the lesser man 'kicks from his path, that it may not come between the wind and his nobility'.

Sims' phrase, 'the soul of goodness in things evil', points to a contradiction of purpose in many life-model stories based on the sufferings of the poor. On the one hand, the stories supposedly protest that people starve in hovels, but they also hymn the virtues of the poor (in comparison with the vanity of Lords and Ladies) in a way that suggests that they are better off being poor. This implication — that there is a kind of moral virtue in poverty — is not limited to life-model narratives; it amounts almost to a literary convention and derives partly from the Christian belief that the rich find it hard to squeeze through the gates of heaven.

One popular classic issued as a life-model set by the Rileys, was *Mother's Last Words*. Behind this set of slides lies the intriguing story of a long-forgotten but once sensationally popular Victorian ballad. Its author, Mary Sewell, is now almost un-known; certainly much less known than her crippled daughter, Anna, author of *Black Beauty*. To Mrs Sewell, a Quaker turned Anglican and friend of leading Temperance reformers, literary fame came late in life. Although she had written a — literally — monosyllabic book, *Walks With Mamma*, for her children, it was her *Homely Ballads* which made Mrs Sewell a household name at the age of sixty. They were written with a serious and avowed intent to inculcate moral purpose, and with a conviction that there existed among the working-classes 'an instinctive love of simple, descriptive poetry and that morally and intellectually it is of more importance to them . . . than to those who have the advantage of a liberal education; to the one it is a luxury — to the other an almost needful relaxation from the severe and irksome drudgery of their daily lot'. Mrs Sewell's faith was vindicated: her *Homely Ballads*, originally printed for private circulation in 1858, had by 1889 sold over 40,000 copies.

Her most remarkable success, however, was to follow. The ballad, *Mother's Last Words* first appeared in 1860, published by Jarrold's of Norwich and London. It sold an unprecedented 190,000 copies. The ballad tells the story of 'two little boys in threadbare clothes', left destitute by the death of their mother (who with her dying breath forgives her erring husband). Her final injunction to her sons is not to 'join the wicked lads' but to 'try for work and always pray'. With the close protection of 'an Angel bright with shining feet', John and Christopher find employment as crossing-sweepers. Winter comes, and the boys are assailed in their virtuous resolve from all sides: the weather and the hurrying public are

equally indifferent; a 'wicked sprite' tempts them to pick pockets; their bare feet are chilblained and the floating vapours of roasting steaks tantalize them. Flesh being weak and all that, John succumbs: he steals some shoes for his little brother's bleeding feet. A guilty conscience and a 'cold, damp sweat' keep them both awake that night and they dream of the devil. They return the shoes and, with naked feet, stand in the wintry wind until their wretched coughing distracts a lady from her blazing fire. Moved to pity, she salves her conscience by a minor sacrifice of two pairs of worn-out shoes, old coats which she would never wear again and four mince-pies, excess to requirements. Such bounty we assume would not have come the boys' way had they kept the stolen shoes. So they are

suitably humble — they bow and scrape and splash back to their hovel, where Christopher duly dies of a decline, leaving John to make his way in the world. He lives a life of Christian sobriety and joins his mother and brother in Paradise.

In all this wallowing sentiment there is never a protest that people should not be allowed to suffer such conditions. On the contrary, the implication is that the poor should accept their lot, since it allows the exercise of virtue in adversity. They should rely on the Providence of God and the promise of ultimate bliss:

> I'm sure you will have daily bread,
> For that the King gave strict command,
> And all the wealth of London town,
> Is in the power of his hand.

Notes and references ——

1 *The Photogram*, February 1899.
2 ibid.

The yellow fog lay thick and dim
O'er London city, far and wide;
It filled the spacious parks and squares,
Where noble lords and ladies ride.

Down seven steep and broken stairs,
Its chill, unwelcome way it found,
And darkened with a deeper gloom,
A low, damp chamber underground.

A glimmering light was burning there,
Beside a woman on a bed;
A worn-out woman, ghastly pale,
Departing to the peaceful dead.

Two little boys in threadbare clothes,
Stood white and trembling by her side,
And listening to his mother's words,
The youngest of them sadly cried.

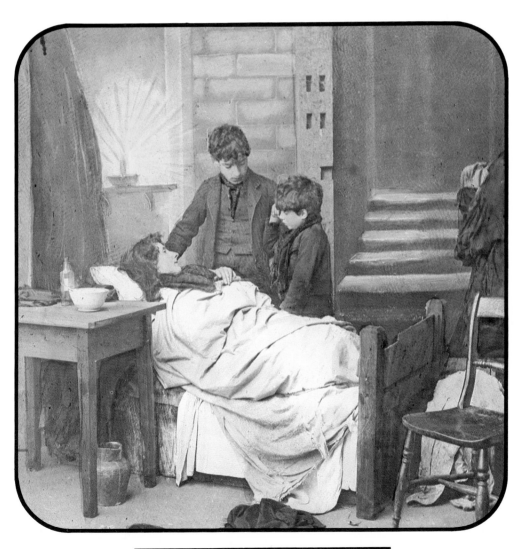

They stumbled up the broken stairs,
And pushed their way along the street.
Whilst out of sight an Angel bright
Walked close behind, with shining feet.

He stood behind them at the door,
And heard the growling overseer,
Then touched his heart with sudden smart,
And brought an unexpected tear.

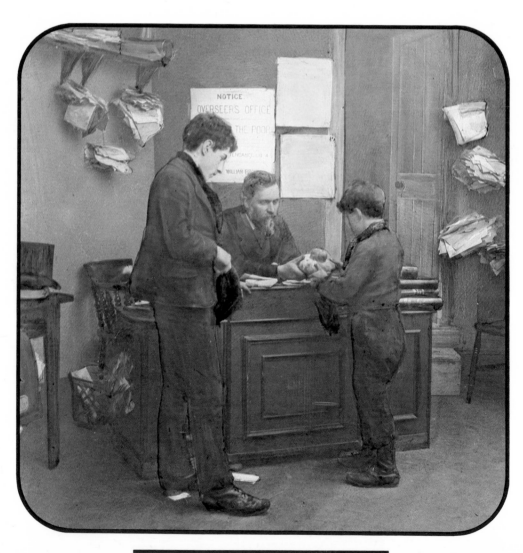

One day a boy came up and said,
'I know a dodge worth two o' that.
Just take to picking pockets, lad,
And don't hold out that ragged hat.'

'What, thieve?' said little Christopher,
'Our dodge is twice as good as that:
We earn our bread like honest folks;'
And so he answered, tit for tat.

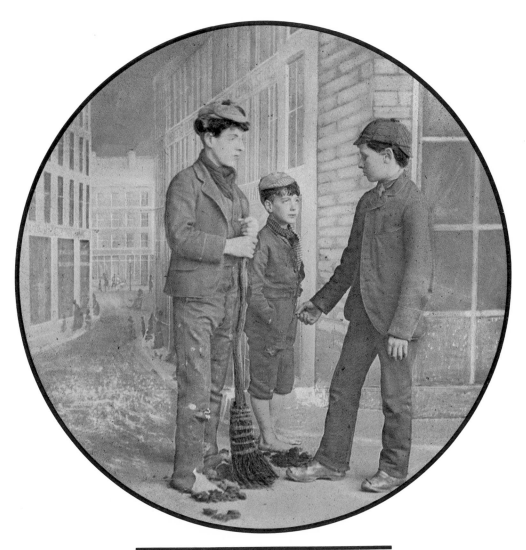

John saw some shoes outside a door —
'They'll just keep my poor Christy warm!'
And, quick as thought, he snatched them up,
And tucked them underneath his arm.

Then pale as ashes grew his face,
And sudden fear rushed on his mind,
He hurried on with quicker pace,
Lest some one should be close behind.

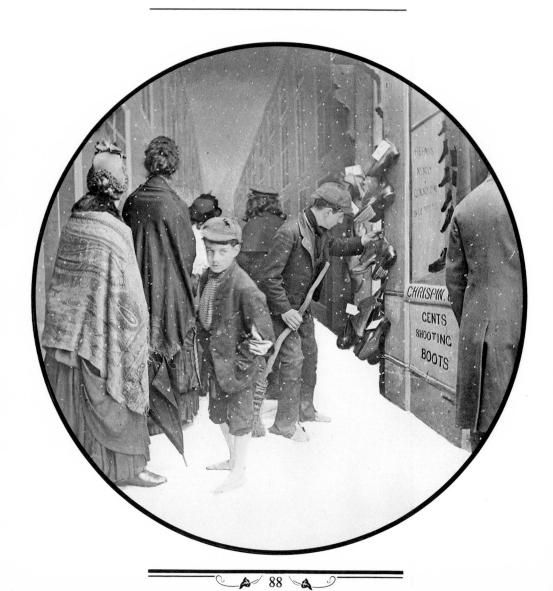

John could not rest; the faintest noise
Made all the flesh upon him creep;
He turned, and turned, and turned again,
But could not get a wink of sleep.

He strained his ears to catch a sound
Of footsteps in the silent night,
And when they came close to the door,
His hair almost rose up with fright.

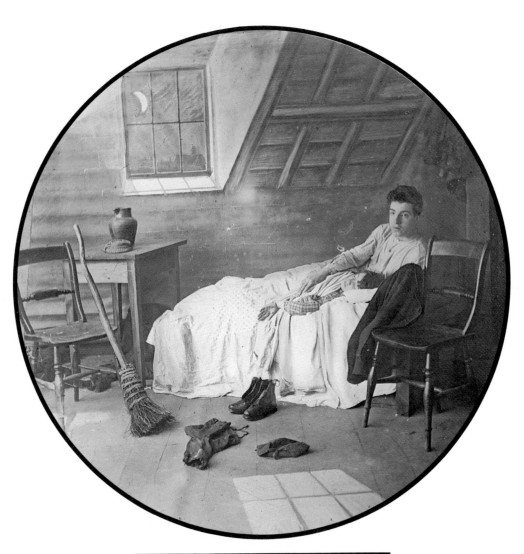

Another of Rileys' popular life-model series was *The Ringing of the Bell*. This popular story by Jas. Milne, is better known as *Jane Conquest*. Riley Brothers produced two versions of it; this one is by Wallace Rothsay. A lonely wife watches her dying child in a humble fisherman's cottage by the sea. Her husband, Willie Thornton, is at sea, and the night is wild and stormy. In despair she weeps and prays. Suddenly, a lurid gleam lights up the room and from the window the wife sees a ship aflame from bow to stern, struggling through the breakers. She leaves her dying child and struggles through the snow to the church belfry to ring the bell and rouse the villagers. The life-boat is launched and saves the fishermen, while Mrs Thornton lies exhausted in the belfry. Her husband, Willie, saved from the burning ship, staggers home and swoons on finding his wife gone. But she is rescued by friendly hands and the couple are reunited. Their child, too, is miraculously cured. (There are twenty-one slides in the complete set.)

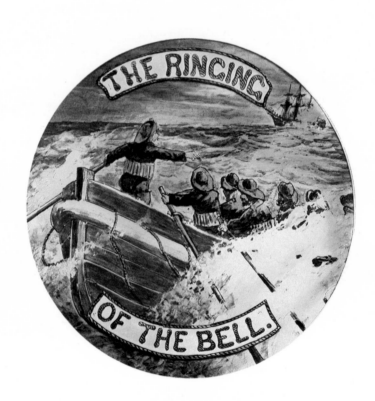

For death had cast its shadow upon the sleeping boy,
And God's own Angels waited to show the path where joy
Unsullied and all-perfect, led to the realms of rest,
Where stand in glory radiant the mansions of the blest.

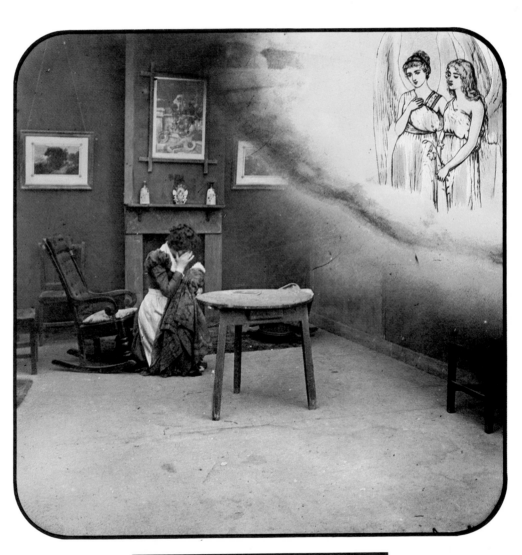

Struggling through blinding sleet and snow, the mother fought her way,
Thinking of that loved, tiny life ebbing so fast away.

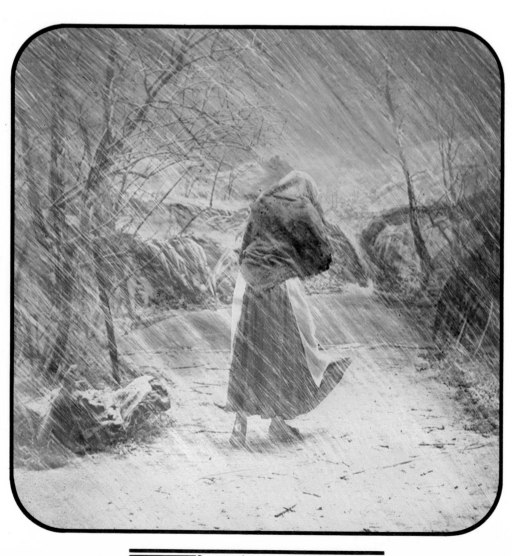

But now she gains the belfry, and ascends the slippery stair,
And grasps with firm but nervous grasp the frozen bell-rope there.
And then the bell starts ringing its message 'cross the snow,
And rouses from its slumbers the village deep below.

'Not dead!' she cries in anguish, then falling on her knee
Beside the cot, her prayer goes up above the stormy sea,
And then with radiant face of joy she thinks of dangers braved,
For God has heard her prayer, and now her darling child is saved.

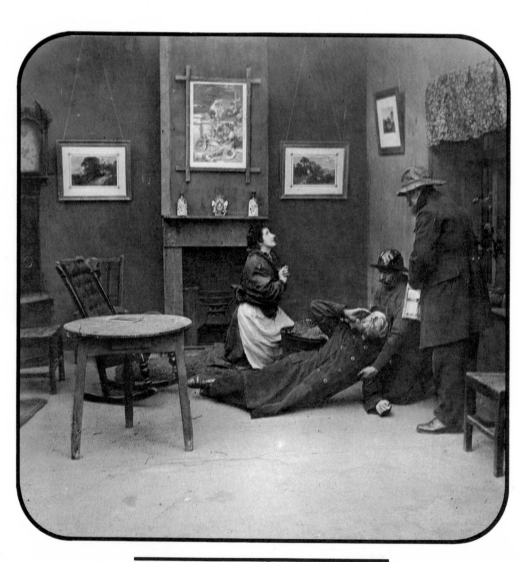

Many of the life-model series were heavily moral in tone, especially those which preached Temperance. *Beware; or The Effects of Gambling* was a cautionary tale published by Jarrold's as one of their series, *Household Tracts for the People*. (Other sobering titles included, *When to say 'No'* and *How people hasten Death*.) *Beware* tells the story of country boy, Dickie Saunders, who takes a third-class ticket to London to make his proverbial fortune. Dickie is corrupted by 'Idle Sam', arrested for selling stolen property, but acquitted on the intervention of the village pastor. (There are twenty-four slides in the complete set.)

Miss Mackintosh, daughter of Dickie's employer in London, asks the cook, Mrs Dawson, to send Dickie on an errand to the chemist. Dickie, however, is with the wastrel, Sam. The cat is demurely unconcerned.

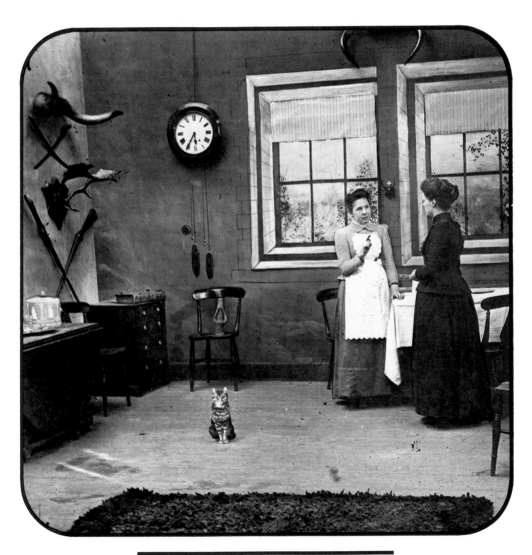

Idle Sam tempts Dickie to try out the raffle in the shop next to the post office.

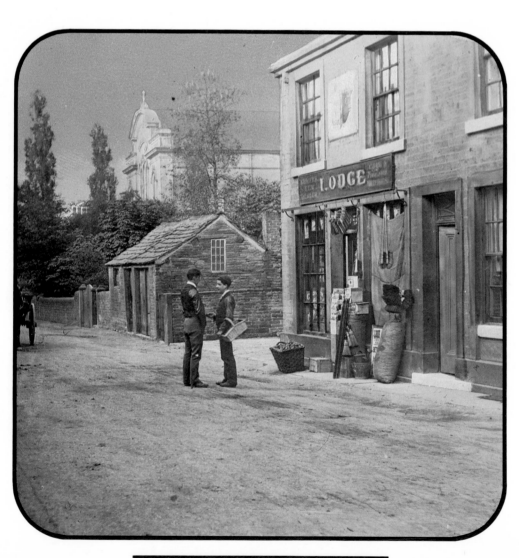

Dickie visits Mr Arnott's stables, ostensibly to admire the horses, but he finds himself drawn into a game of dice with Sam.

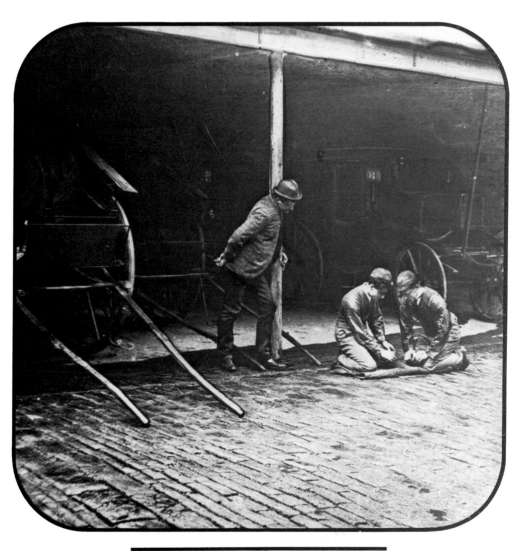

Ben and Ruth Saunders, expecting to hear that their son is to visit them, receive instead a letter telling them of his arrest.

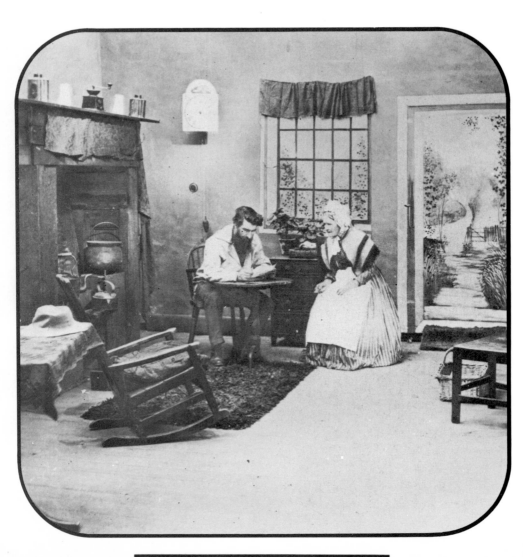

Excursions, Rambles and Tours

Nineteenth-century reformers who investigated the plight of the poor often saw themselves as explorers in an undiscovered country, 'a dark continent that is within easy walking distance of the General Post Office'.[1] It seemed to some that distant, dark continents — Africa and Asia — were much more accessible than the streets of 'Darkest England'[2] that lay just round the corner: 'But O Cook. O Thomas Cook and Son, pathfinders and trail-clearers, living sign-posts to all the world, and bestowers of first aid to bewildered travellers — unhesitatingly and instantly, with ease and celerity, could you send me to Darkest Africa or Innermost Thibet, but to the East End of London, barely a stone's throw distant from Ludgate Circus, you know not the way.'[3]

Less than twenty years before the Rileys sold a lantern slide, Thomas Cook took his first, small party round the world, coincidentally in the same year that saw Jules Verne's *Round the World in Eighty Days*. The journey was not without its longueur: twenty-four days non-stop on board the *S.S. Colorado* across the Pacific at nine miles per hour. Some of the sights, too, were not what Cook would wish to advertise in his *Excursionist*, particularly the heathen idolatry and 'shameless dancing girls' in Benares. For all that, this pioneering journey was symbolic of the way in which Thomas Cook's organization, both at home and abroad, had shrunk the globe.

The manic building of railways from the 1840s and the furious competition for passengers enabled Thomas Cook and others to bring excursion travel within the reach of the working classes. From the time of his first, one-shilling, nine-coach excursion from Leicester to Loughborough (and back), Thomas Cook saw travel as an agent of Temperance and of more general social reform. He offered those who worked fifty and sixty hours a week in mills and factories the opportunity of 'going abroad to behold the handiwork of the Great Supreme'; such pleasures had traditionally been the preserve of the 'sons of fashion', who, 'after their debaucheries or voluptuousness, had to avail themselves of a change of air and scenery to recruit their exhausted powers'.[4] When he died, in 1892, Thomas Cook ruled a far-flung empire, 'the Julius and Augustus of modern travel', although *The Times* questioned whether he had achieved his moral aims: 'The world is not altogether reformed by cheap tours, nor is the inherent vulgarity of the British Philistine going to be eradicated by sending him with a through ticket and a bundle of hotel coupons to Egypt and the Holy Land . . . If only Messrs. Cook could guarantee a benefit to mind and manners as easily as they can guarantee a comfortable journey.'[5]

Through Riley Brothers' lantern slides audiences could travel the world even more comprehensively

than with Thomas Cook, from the Afghan frontier to *One Thousand Miles up the Congo*. For those unable to find 220 guineas and 220 days to travel with Cook's, Rileys guaranteed a briefer and cheaper *Round the World in a Hundred Minutes*. These tours by magic lantern, like Cook's, were offered as edification: many of the accompanying lectures were written by practising missionaries. More exotic views, like the Caravansary at Murzah-rabat or Beycos Kiosque, would bring no thrill of recognition to audiences in Bradford; they served instead to show the poor lot of those not privileged to have been born under an English heaven. Closer to home, the Rileys also showed nostalgic glimpses of local *Rambles in Yorkshire* and enticing vistas of places tantalizingly within reach, like the South Coast, the Lake District and Killarney.

Through Riley Brothers' lantern slides audiences could remind themselves, by gaslight in winter, of warmer prospects in summer. More importantly, for those imprisoned in cities, the slides flashed nostalgic images of what before the Industrial Revolution had been a short walk away — quiet fields and purer air. Many of the slides are of quietly anonymous country scenes: woodland, meadow, mountain and stream. For the Victorians all landscapes, whether paintings or photographs, could be 'the townsman's paradise of refreshment' where 'his hard-worn heart wanders out free, beyond the grim city world of stone and iron, smoky chimneys, and roaring wheels, into the world of beautiful things'.[6]

Strange, then, that so many of the landscapes contain a reminder of man, in the form of old buildings, especially halls, castles and churches.

For the Victorian eye, however, the stonework would not be intrusive. Though clearly an artefact, a historical monument served 'to tell us of nature; to possess us with memories of her quietness; to be solemn and full of tenderness, like her, and rich in protraitures of her; full of delicate imagery of the flowers we can no longer gather . . .'[7]

Notes and References

1 George Sims, *How the Poor Live*, 1883.
2 General Booth, *In Darkest England and the Way Out*, 1890.
3 Jack London, *The People of the Abyss*, 1903.
4 Thomas Cook, quoted in *The Romantic Journey*, Edmund Swinglehurst, 1974.
5 *The Times*, 10 July 1893.
6 Charles Kingsley on the National Gallery, 1848.
7 John Ruskin, *The Stones of Venice*, 1851–3.

The start of the journey
Victoria Station

Hastings

Battle Abbey

Eastbourne

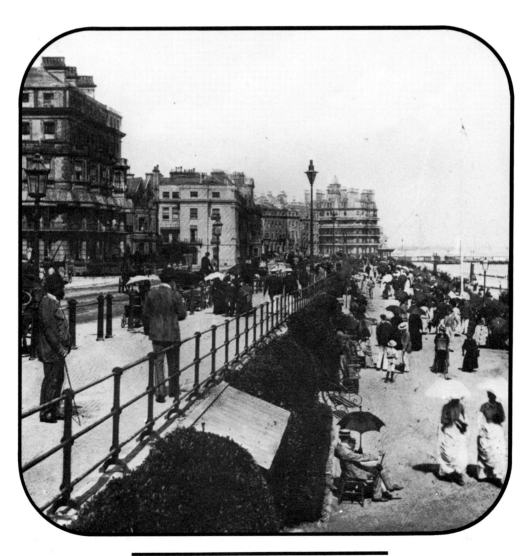

Lewes

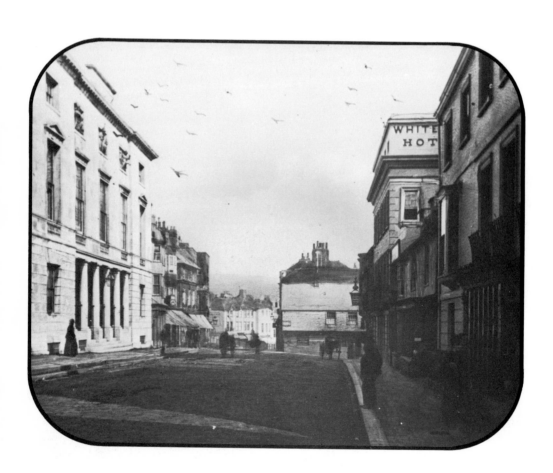

Littlehampton

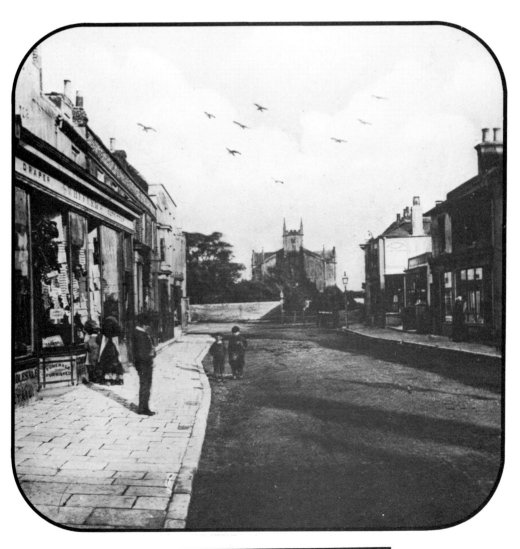

Portsmouth Dockyard

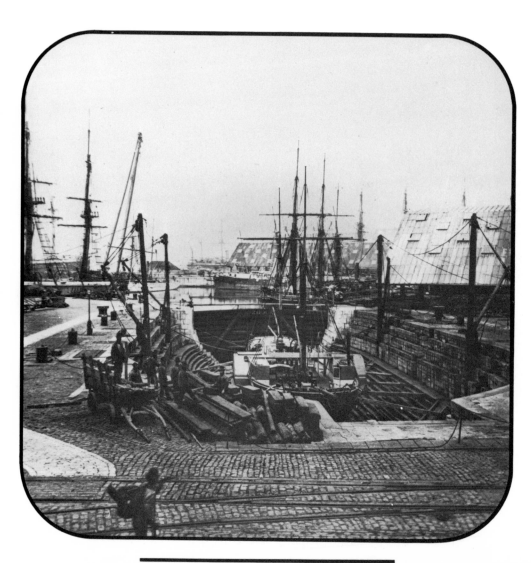

Bristol — Wine Street
(from *Great Towns and Cities*)

Brighton
The Grand Aquarium

Brighton
The Chain Pier

Battle Village

Seaford

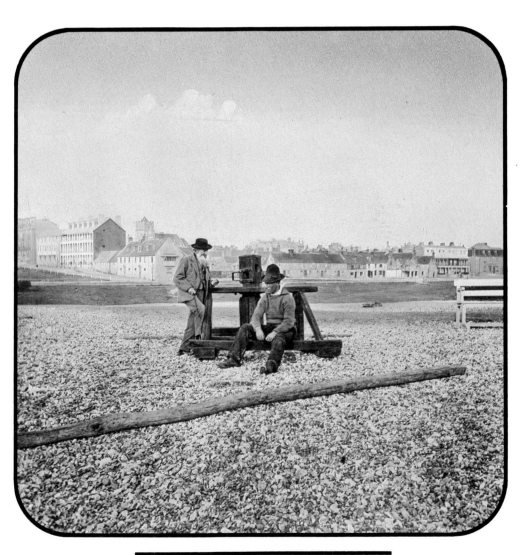

Amberley

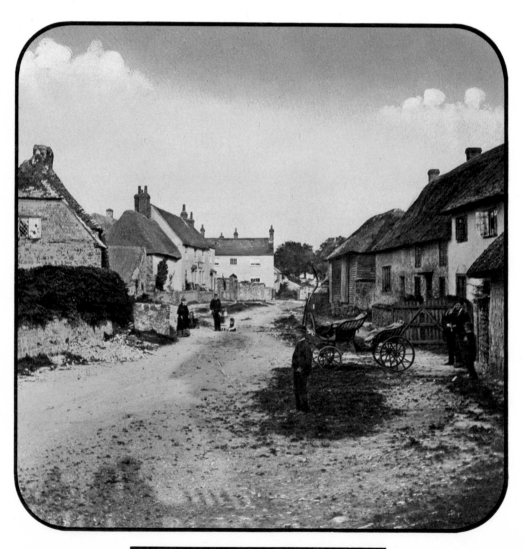

Havant

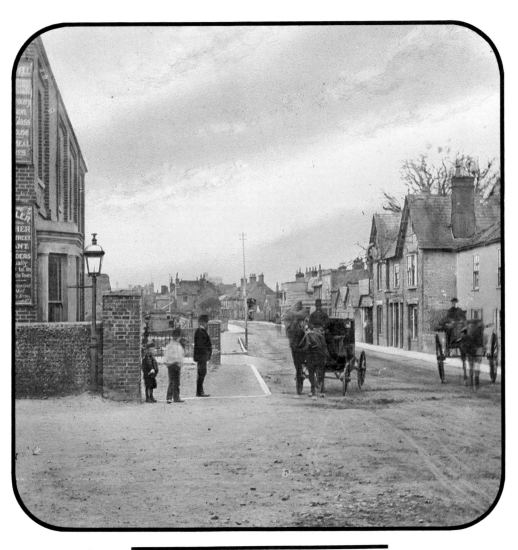

Hayling Beach

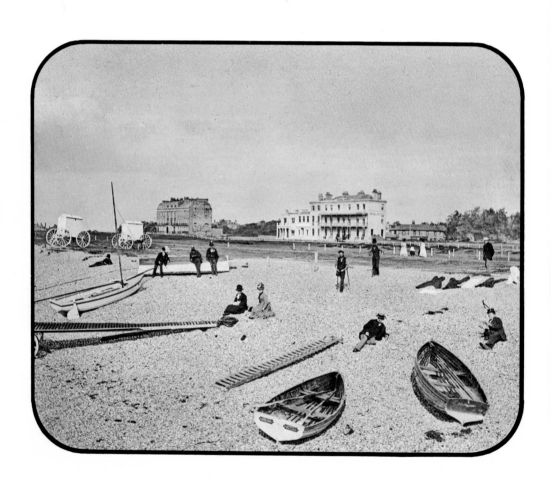

Shanklin

Sandown

Killarney

(from *A Tour of Ireland*)

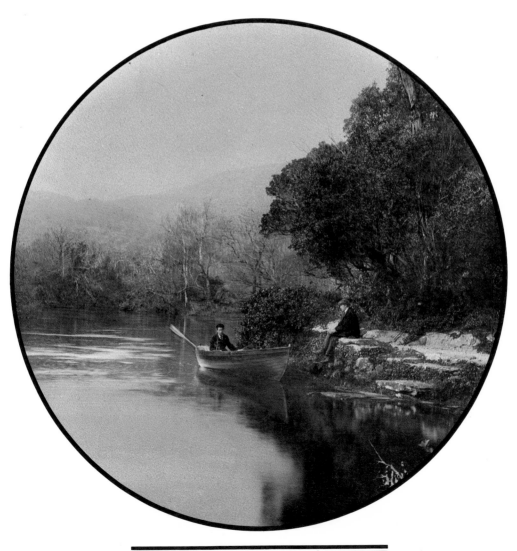

The Lake District

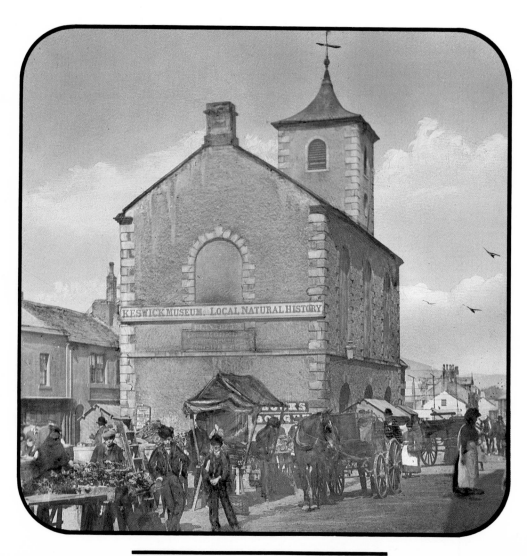

The Lake District

Lynmouth

(from *Devon and Cornwall*)

Padstow

Venice

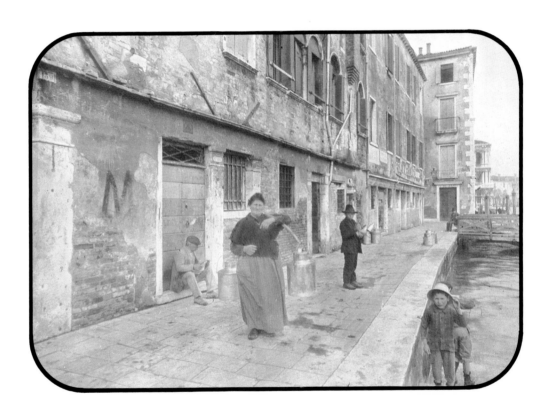

Plymouth

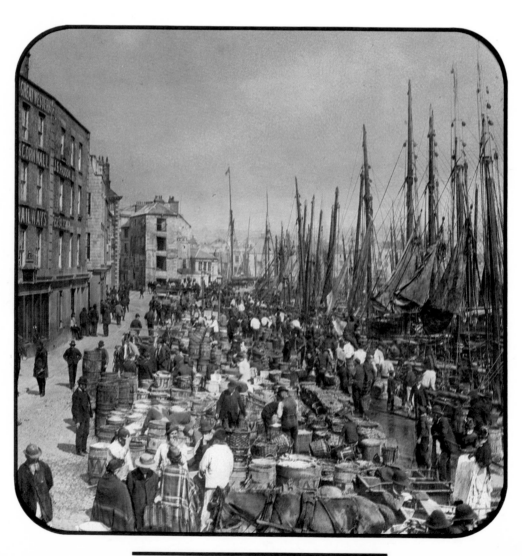

A Reed Boat-house
(from *Round Britain in a Yacht*)

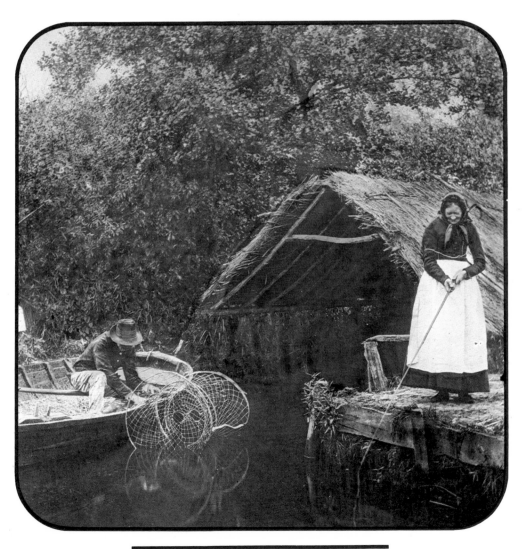